The Darkness And The Light

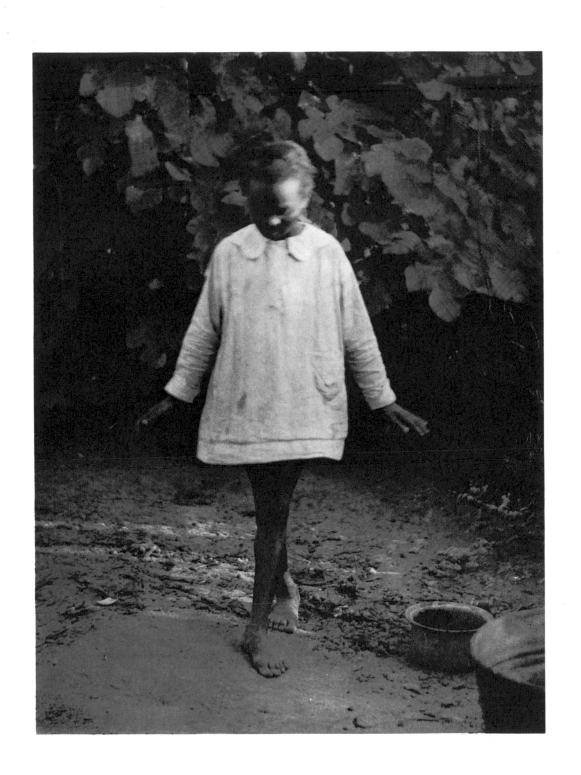

The Darkness And The Light

PHOTOGRAPHS BY DORIS ULMANN

PREFACE BY WILLIAM CLIFT

with *A New Heaven and a New Earth*

BY ROBERT COLES

Aperture

The photographs were sequenced and the book was brought together by William Clift.
The design is by Jane Byers Bierhorst.

Aperture, Inc., publishes a Quarterly of Photography,
portfolios, and books to communicate with
serious photographers and creative people everywhere.
A catalog of publications is available upon request.

Copyright © 1974 by Aperture, Inc.
All rights reserved under International and Pan-American Copyright Conventions.
Published in the United States by Aperture, Inc., Elm Street, Millerton, New York 12546
and simultaneously in Europe by McGraw-Hill Book Company GmbH, Düsseldorf, Germany
and in Canada by Gage Trade Publishing, Agincourt, Ontario.

Library of Congress Catalog Card Number 74-76878
ISBN Numbers: Clothbound 912334-60-6/Paperbound 912334-64-9
Manufactured in the United States of America
98765432
First printing

Acknowledgments

The assistance of the following people has helped to make this book a reality:

Robert O. Ballou
Otelia Barnes
Eleanor Caponigro
Vida Clift
Laura Gilpin
Minna Goosman
Mrs. Charles J. Maddox
Beaumont and Nancy Newhall
John Jacob Niles
Clarence White, Jr.
Mrs. William Young
Dora Zeigler

Preface

"A face that has the marks of having lived intensely, that expresses some phase of life, some dominant quality or intellectual power, constitutes for me an interesting face. For this reason the face of an older person, perhaps not beautiful in the strictest sense, is usually more appealing than the face of a younger person who has scarcely been touched by life."* Thus Doris Ulmann described her approach to photography.

When so many photographers these days are delving into the emptiness, sordidness and apparent hopelessness of man, it is refreshing to see pictures which offer us a quiet but deeply felt human experience. My own first contact with the photographs of Doris Ulmann in 1964 impressed me with an intense sense of life. At a crafts museum off the Blue Ridge Parkway I saw a series of her Appalachian portraits. I was startled as much by

*Dale Warren, "Doris Ulmann: Photographer-in-Waiting," *Bookman* (Oct. 1930).

the very existence of such pictures as by the simple beauty and force of the people they portrayed. The enthusiasm generated by this experience led me to search out Ulmann's other work, a pursuit which resulted in the discovery of her study of the plantation black people. I recognized in these pictures not simply a dated human record of interest only to sociologists or photography historians, but something of an emotional and definitely universal value. The images in this volume are evidence of a black heritage so rich one wonders why it has been forgotten.

Doris Ulmann was born on May 29, 1882, of a wealthy New York City family. She went to public schools and in 1900 enrolled in the Teacher Training Department of The Ethical Culture School, from which she graduated in 1903. There, in 1902, she studied with Lewis W. Hine, who taught nature study and photography. Later Ulmann married a doctor, Charles H. Jaeger, and, thinking she would teach psychology, began to study at Columbia University, though not for long. Her interest in photography, which had begun rather casually with a simple box camera, took hold of her when, in 1914, she took a course in the art of photography with Clarence H. White at Columbia Teachers College. Ulmann became one of White's most devoted pupils and later attended and lectured at The Clarence White School of Photography in New York City. Among White's other pupils were Margaret Bourke-White, Ralph Steiner and Laura Gilpin. Gilpin remembers well a quiet Doris Ulmann who sat in on a class she herself was attending in 1916. In 1918 Ulmann made photography her profession. She became a member of The Pictorial Photographers of America, an offshoot of the Photo Secession. Clarence H. White was its first president.

Between 1918 and her death on August 28, 1934, Doris Ulmann gave herself completely to photography, predominantly portraiture. She made a record of certain human types that, she felt, portrayed a quality of life Americans were about to lose and forget—a quality measured not by wealth or achievement but by human character. This record consists primarily of the remarkable portraits she made of Appalachian craftsmen and Southern blacks.

Her earlier body of photographs had been devoted to the distinguished men of her day: doctors, lawyers, men of science like Einstein, poets and writers such as Tagore, Robert Frost, Oliver La Farge, Thornton Wilder, Sherwood Anderson. Ulmann photographed them in their offices, or laboratories, but more often in her Park Avenue apartment, always using natural light. By 1925 three handsome portfolios had been published: *Twenty-Four Portraits of the Faculty of Physicians and Surgeons of Columbia University*

(1919), *A Book of Portraits of the Medical Faculty of the Johns Hopkins University* (1922) and *A Portrait Gallery of American Editors* (1925). All three were limited editions, with the photographs reproduced in gravure. This work was a natural outgrowth of Ulmann's life in New York City. Dr. Jaeger was a leading orthopedic surgeon and an amateur photographer working with the bromoil process. He too was a member of The Pictorial Photographers of America. Photographs by Doris U. Jaeger and Charles H. Jaeger appear side by side in several of the annuals published by this organization. Together they formed a close friendship with Clarence H. White. Dr. Jaeger was the Whites' family physician and Ulmann leaned heavily on White, constantly seeking his advice and support. She dedicated her first portfolio to this great teacher with the words "In grateful appreciation of his encouragement, his sympathy, and his unfailing inspiration, the expression of his devotion to the highest ideals of art and life."

Doris Ulmann's first pictures, as represented in the three portfolios, were rather formal, half-length portraits. The subjects present an engaging appearance, but the photographs do not penetrate much beyond it. From the perspective of her later work one feels something missing in Ulmann's attitude toward her prestigious sitters. Lotte Jacobi's portraits of Einstein, Robert Frost and other intellectuals reveal the real poetry of the person in a way Doris Ulmann's do not. She herself said in 1930, "I am not interested exclusively in literary faces, because I have been more deeply moved by some of my mountaineers than by any literary person, distinguished as he may be."*

By 1925 Clarence H. White had died, and shortly thereafter Doris Ulmann and Dr. Jaeger were divorced. On her own, Ulmann began to pursue an entirely new, more personal direction in her photography. The emphasis of her work became documentary. To Allen Eaton, with whom she worked closely in 1933 and 1934 to record people working with handicrafts, she once made the statement: "I am of course glad to have people interested in my pictures as examples of the art of photography, but my great wish is that these human records shall serve some social purpose."**

The Appalachian and black photographs make it clear that Ulmann's purpose was not social commentary. Her aim was not to record conditions—the effects of poverty, the black-white problem, the misery of people's existence; rather, her intent was to show the wealth of individual character belonging to her subjects and how they had come to possess it.

*Warren, "Doris Ulmann: Photographer-in-Waiting."
**Allen H. Eaton, "The Doris Ulmann Photograph Collection," *The Call Number,* 119, 2 (Spring 1958).

Doris Ulmann's heart and real interest were increasingly drawn away from the City. She made a lovely series of portraits in the Dunkard, Mennonite and Shaker settlements found in Virginia, Pennsylvania, New York and New England. Frequent trips South— first into the Appalachian mountain states and later Louisiana and South Carolina— brought her in touch with the world of mountain craftsmen and musicians, remnants of an Anglo-Saxon, Gaelic and Celtic tradition; in the Deep South she met the Gullah Negroes, former slaves who had come to the United States from what is now Liberia and who had developed their own distinct dialect, the Gullah. The nature of the lives of such people, which included so much poverty and hardship, had brought them closer to the soil, their crafts, and to God. Doris Ulmann felt compelled to illuminate with her camera these un- familiar pockets of American culture. She envisioned a gradual blending of the races in which these types of people would lose their particular distinctiveness. Had she lived out her intentions, she would have photographed the "Cajuns" (Acadians) of Alabama and Louisiana, and the Creole aristocrats of New Orleans.

Between 1925 and 1934, the period of her most concentrated and personal work, Doris Ulmann made long, arduous trips by automobile from New York into these back-country areas to meet people and ask them if she might take their pictures. John Jacob Niles, the great collector of American folk ballads, accompanied her to help with the view camera and heavy $6^{1}/_{2} \times 8^{1}/_{2}$ glass plates, and at the same time to continue his own research. Her health was sacrificed for her work. She suffered from a severe stomach ulcer, and the fa- tigue of travel and work aggravated her condition.

Eventually Doris Ulmann collaborated with Julia Peterkin, the Southern novelist, and later with Allen Eaton, champion of the rural handicrafts movement, on projects resulting in her two finest publications: *Roll, Jordan, Roll* (1933) and *Handicrafts of the Southern Highlands* (1937). With little interest in her own welfare she dedicated herself and all the necessary funds from her estate to the making of over ten thousand negatives of these subjects, much as Edward S. Curtis had been doing with his massive study of the North American Indian. Both had given up their professional life in the City to document what they considered to be remarkable but vanishing cultures in America.

Although Ulmann's photographs of blacks were made all over the South, a great many are from the Lang Syne Plantation, located on a peninsula at the junction of the Congaree and Wateree rivers—the "backwater" country of South Carolina near Fort Motte. Julia Peterkin, winner of the Pulitzer Prize in 1929 for her novel *Scarlet Sister Mary*, was the owner of the plantation. According to Niles, Peterkin met Ulmann in New York City at a

publishers' tea, where she suggested Ulmann do a study of the four hundred or so Gullah Negroes who lived and worked on Lang Syne. It became a portrait of a separate and independent group of blacks at a certain time and place, not a general comment on all blacks in America.

Roll, Jordan, Roll, with text by Julia Peterkin, was an outgrowth of this project. It was printed in two editions: the first, for general circulation, contained seventy-two photographs, very poorly reproduced; the second, a deluxe edition limited to three hundred and fifty copies signed by Peterkin and Ulmann, was of larger format than the first and included ninety superb hand-pulled gravures. The plates in the present volume have been selected and reproduced directly from these, since very few of the original prints still exist.

In Ulmann's black photographs there is an atmosphere of love which seems to envelop her subjects. Her attitude toward people was reflected in her delicate use of natural light and the soft-focus lens. This lens, which has not been widely used for years, was designed to induce spherical aberration—that is, a lack of sharpness at the edges of the image. Thus a selected area of the image could be sharp, while elsewhere there was a gradual softening of the image. Wide open, the soft lens offered great selectivity; stopped down, there could be relative sharpness throughout the image. With the commonly used modern lens, sharpness is obtained over the entire plane of focus.

Lang Syne Plantation was far from the city and isolated from the mainstream of American life. The Gullahs there had a pride in their own language and a pride in themselves and their heritage. They had little desire to emulate white people. Few had left the plantation to go "up the road" to Harlem or Chicago. The complex forces which operate in big-city slums—unemployment, degradation and anonymity—were not upon them.

Doris Ulmann was inspired by the simplicity of these black people. Their devotion, humility and fervor before God, and a particular sense of inner strength in the midst of enormous difficulties, touched her deeply spiritual nature. She seemed especially interested in their rituals: baptism, foot-washing and spirituals. John Jacob Niles reports that she had a strong attraction to the ideas of Zen and to Suzuki, who was just then becoming known.

In addition to religious concerns, the other important aspect of life on this plantation was the contact its workers had with the soil. There were no large farm machines to come between man and the earth. Little of what we call progress had come their way. At Lang Syne asparagus, cotton, wheat, oysters and fish were the products of their labor; but

their real attainments were fortitude, human warmth and a sense of community. Doris Ulmann has left us a clear and consistently strong record of the quality of their life. Even as the handicrafts meant so much to the lives of the Appalachian people—so for the Gullah, working with the land and confronting the forces of nature and the supernatural were fundamental to building character.

There is a story about Doris Ulmann and one of her black subjects who posed in a long, white robe. The subject's name was Sister Nancy. "When Nancy pursed her lips and assumed the rigid stare she thought suited to the occasion, Miss Ulmann told her that it would be quite all right for her to talk and move her head slightly if she was uncomfortable. Nancy, however, had ideas of her own. 'No,' she answered. 'I will not talk and I will not move. Something tells me to be quiet. This is God's work!' "*

William Clift
Santa Fe, New Mexico

*Warren, "Doris Ulmann: Photographer-in-Waiting."

Photographs by Doris Ulmann

If I ascend up into heaven, thou art there: if I make my bed in hell, behold, thou art there.

If I take the wings of the morning, and dwell in the uttermost parts of the sea;

Even there shall thy hand lead me, and thy right hand shall hold me.

If I say, Surely the darkness shall cover me; even the night shall be light about me.

Yea, the darkness hideth not from thee; but the night shineth as the day: the darkness and the light are both alike to thee.

—*Psalm 139, Verses 8–12*

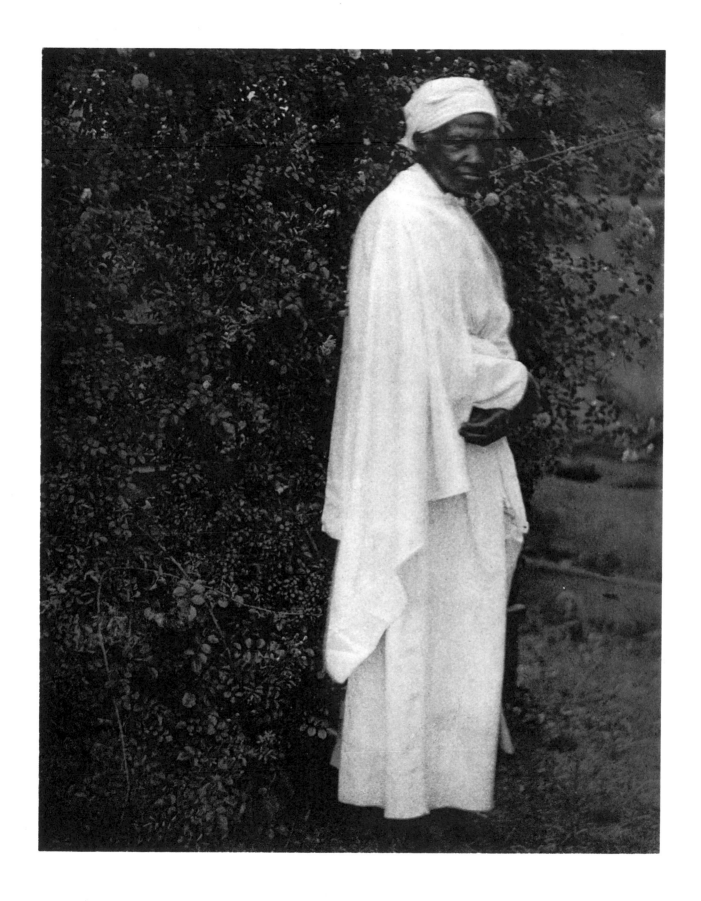

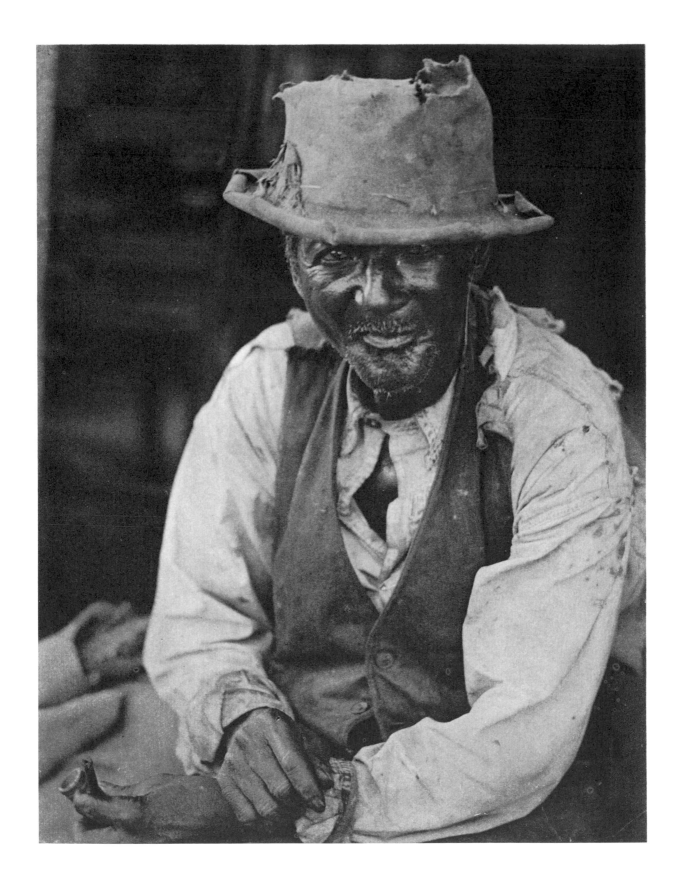

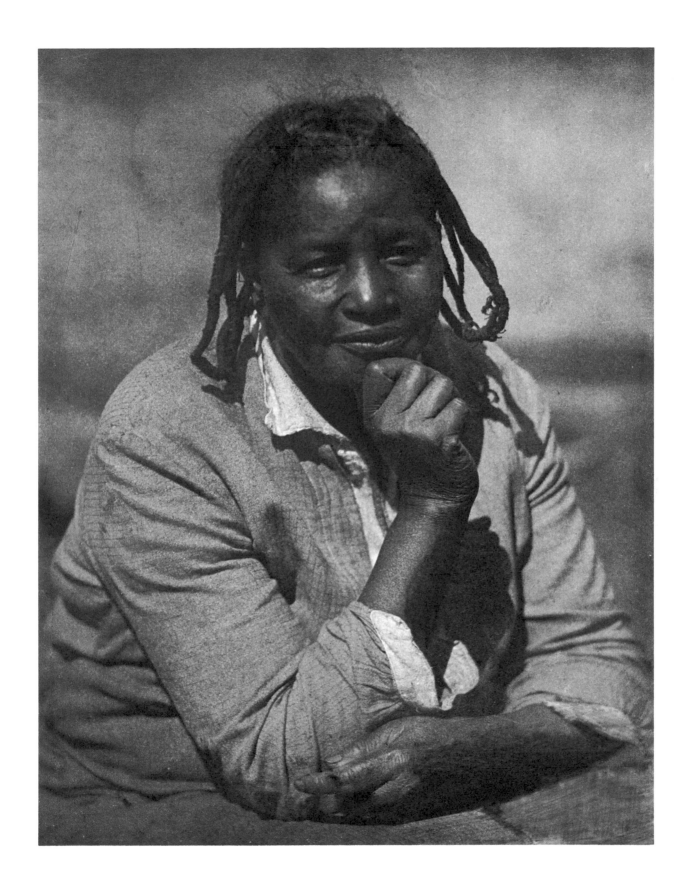

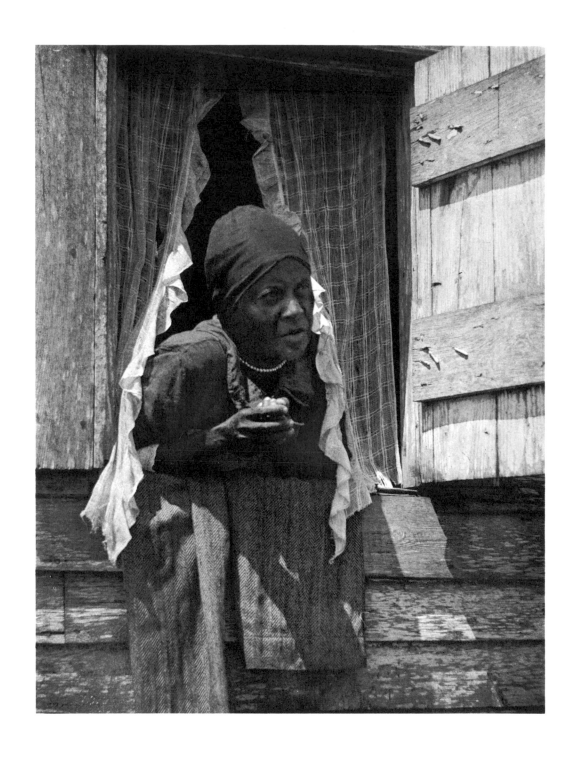

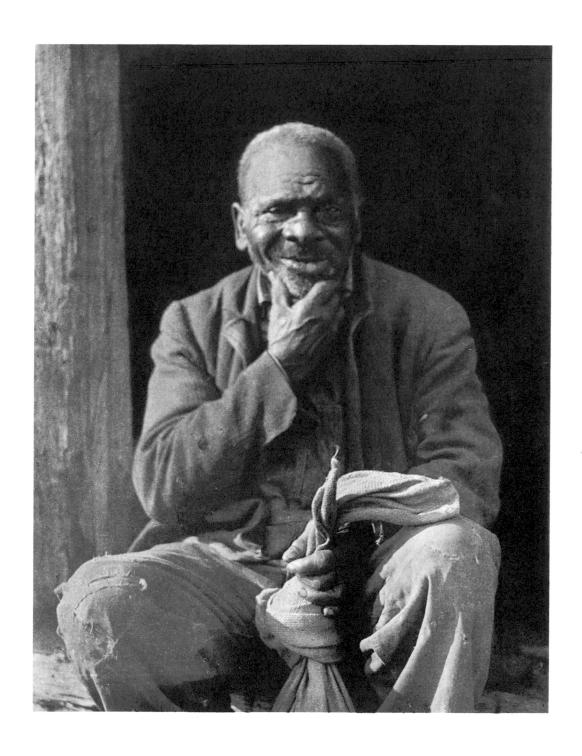

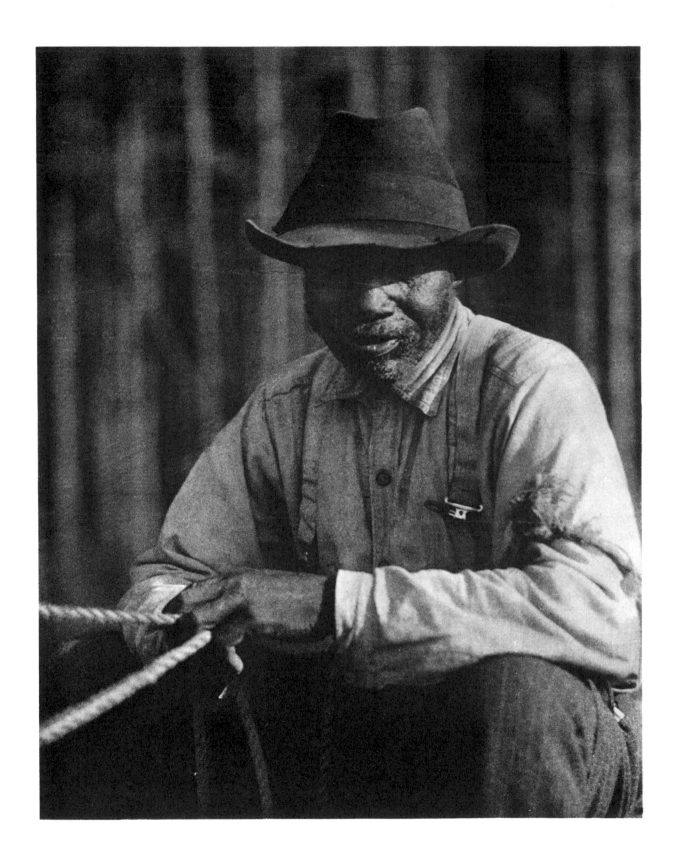

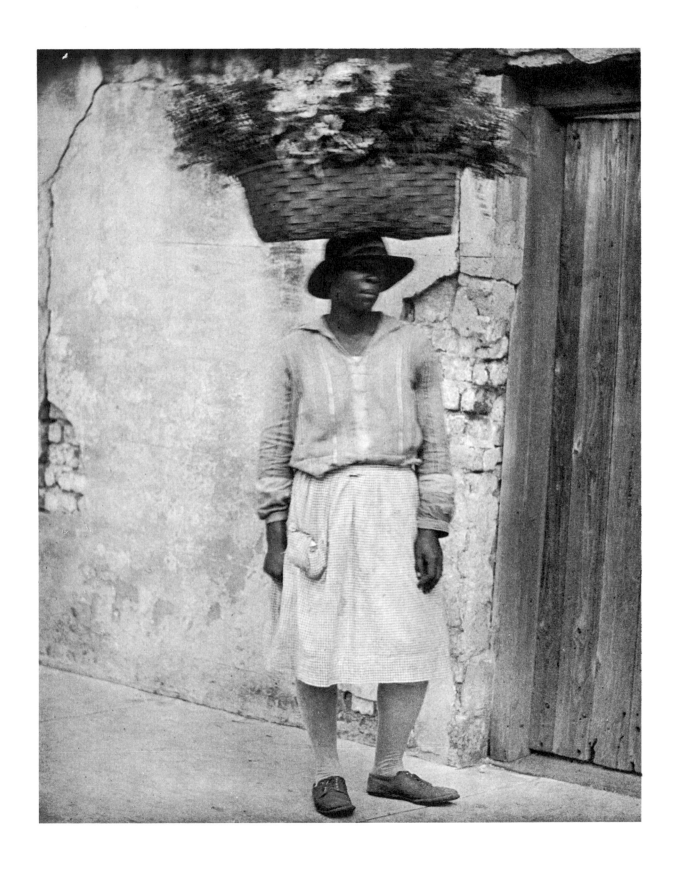

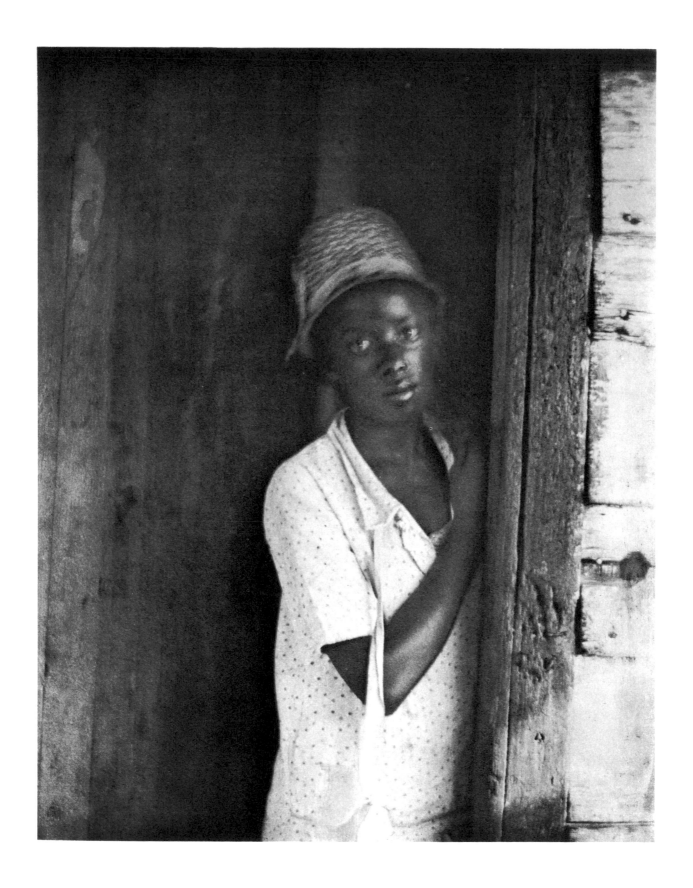

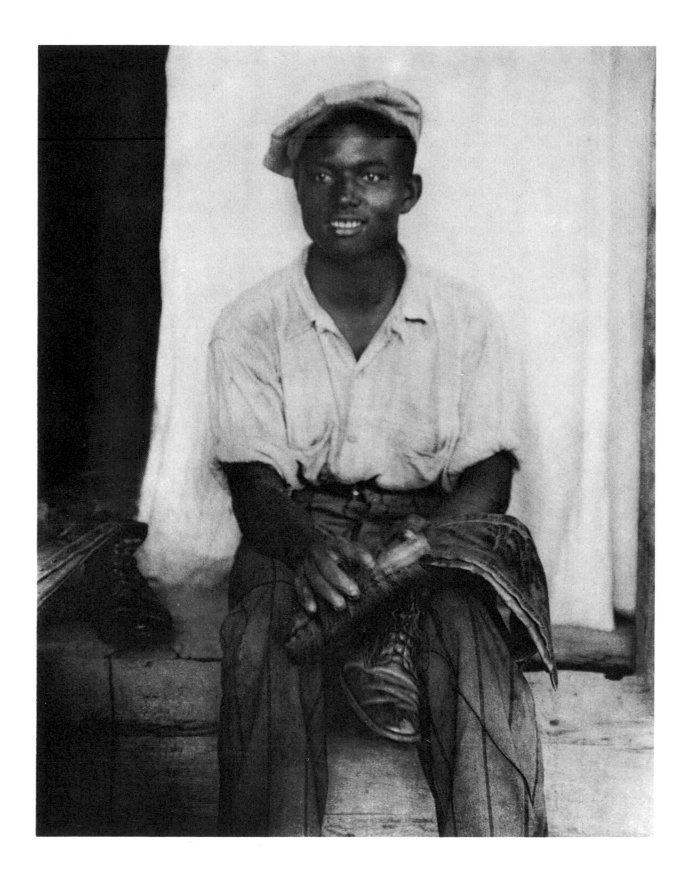

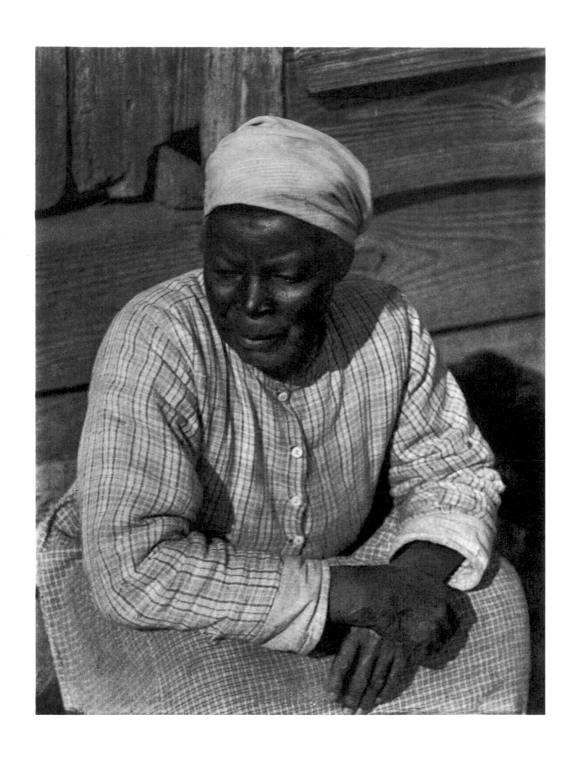

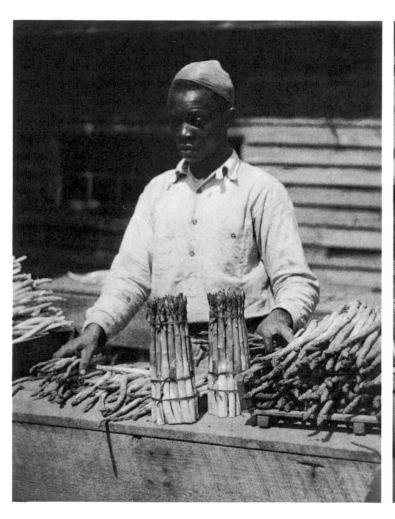
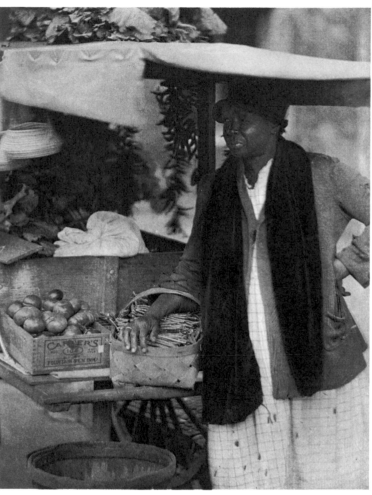

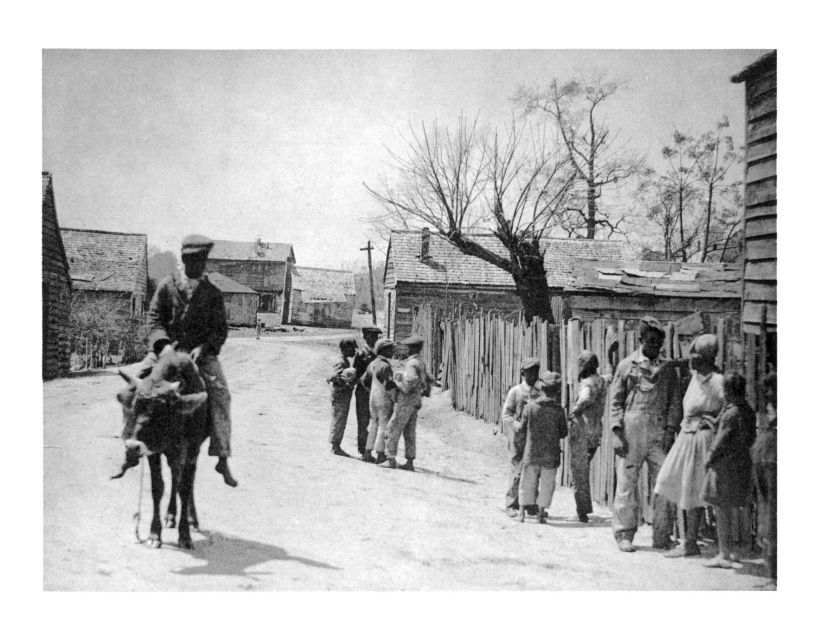

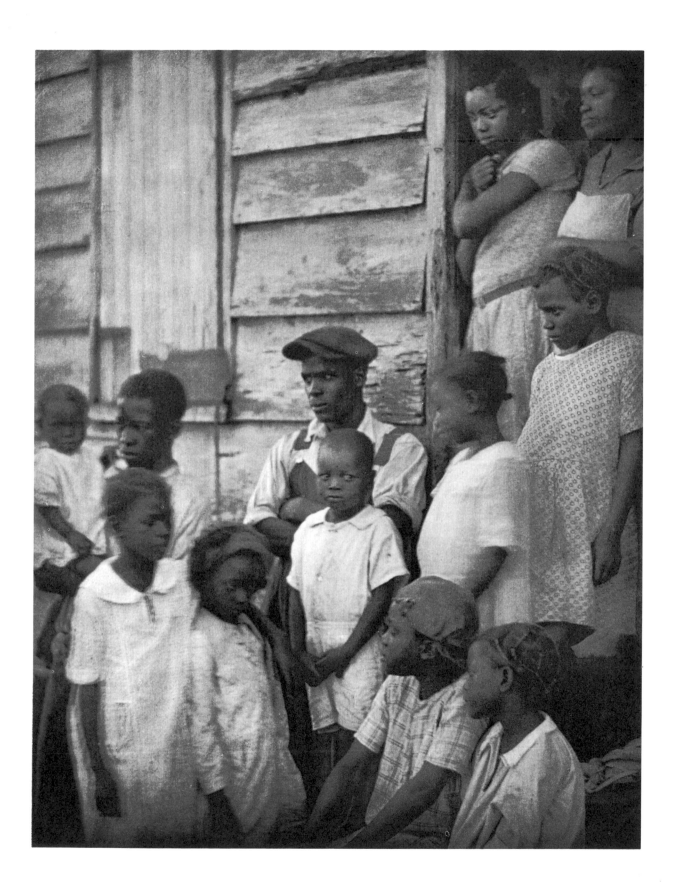

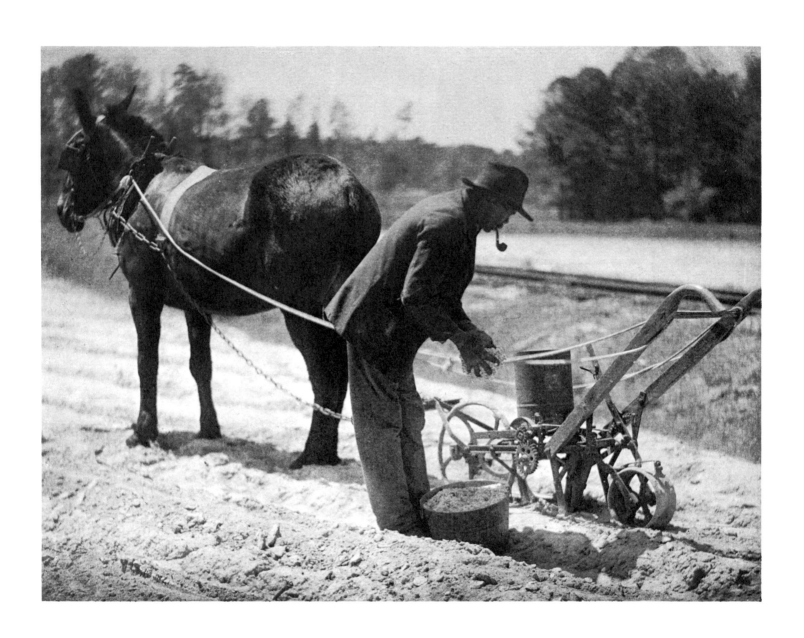

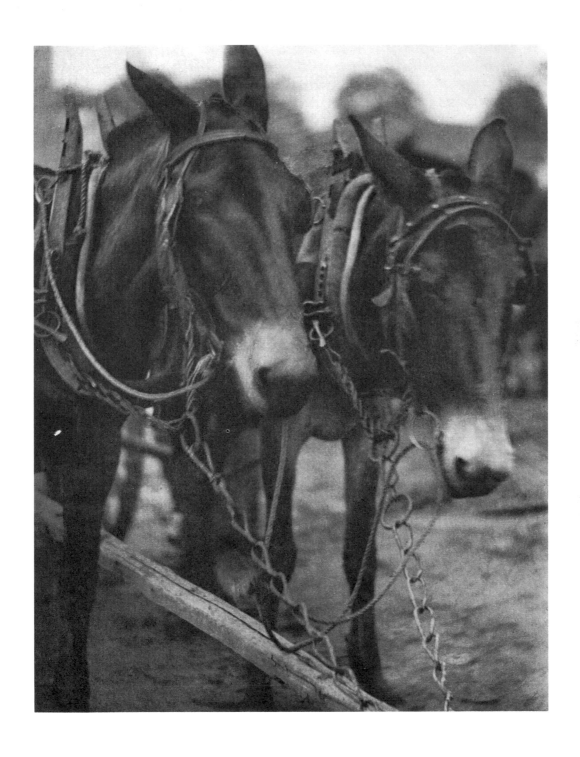

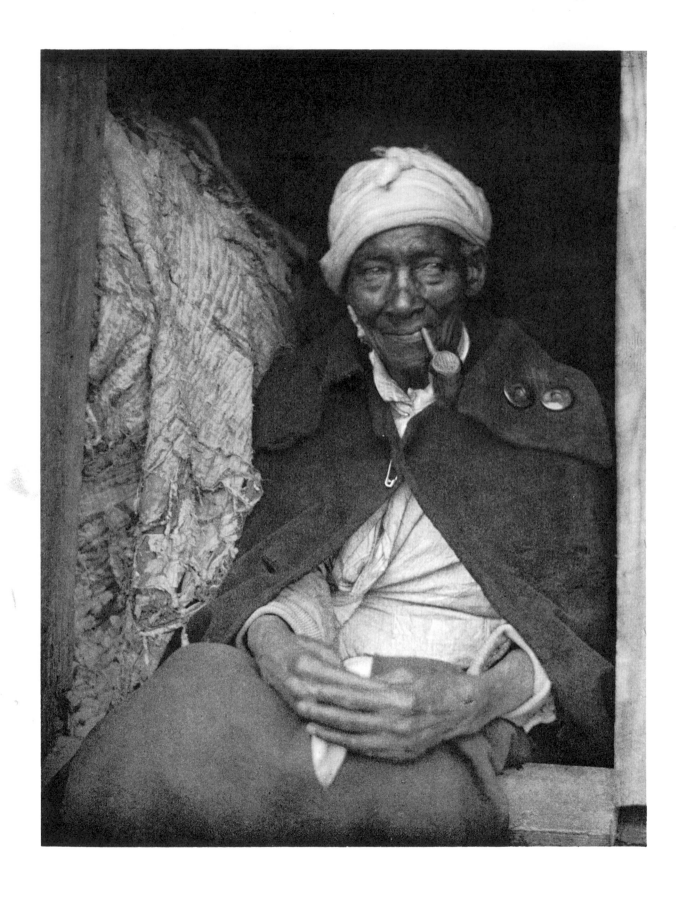

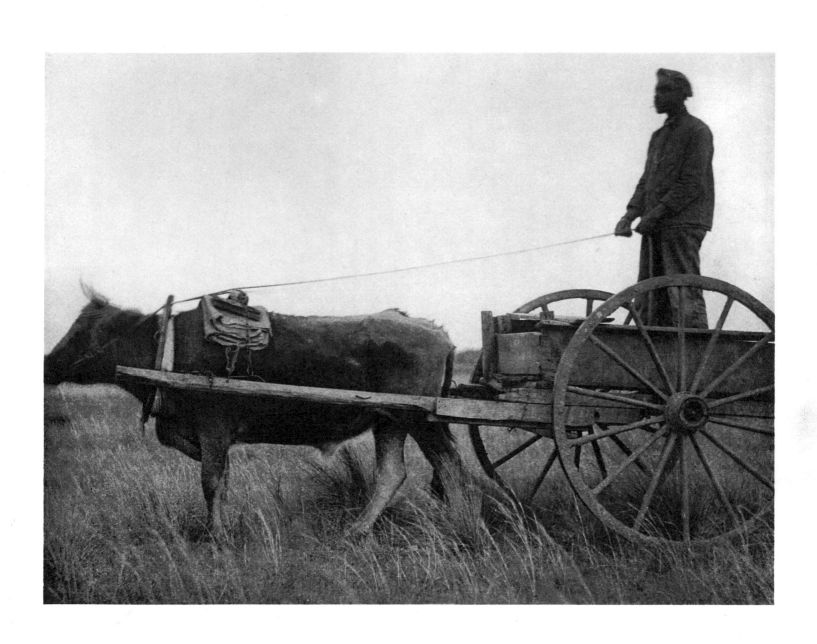

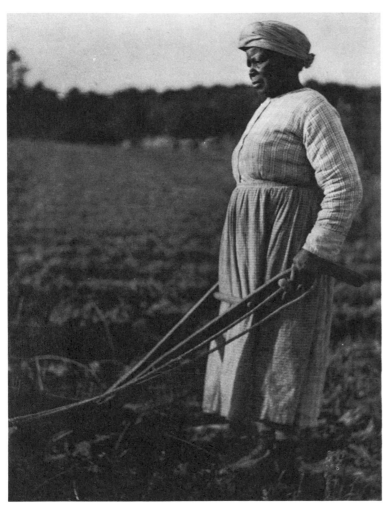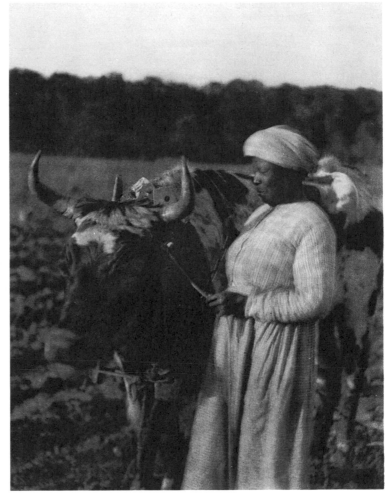

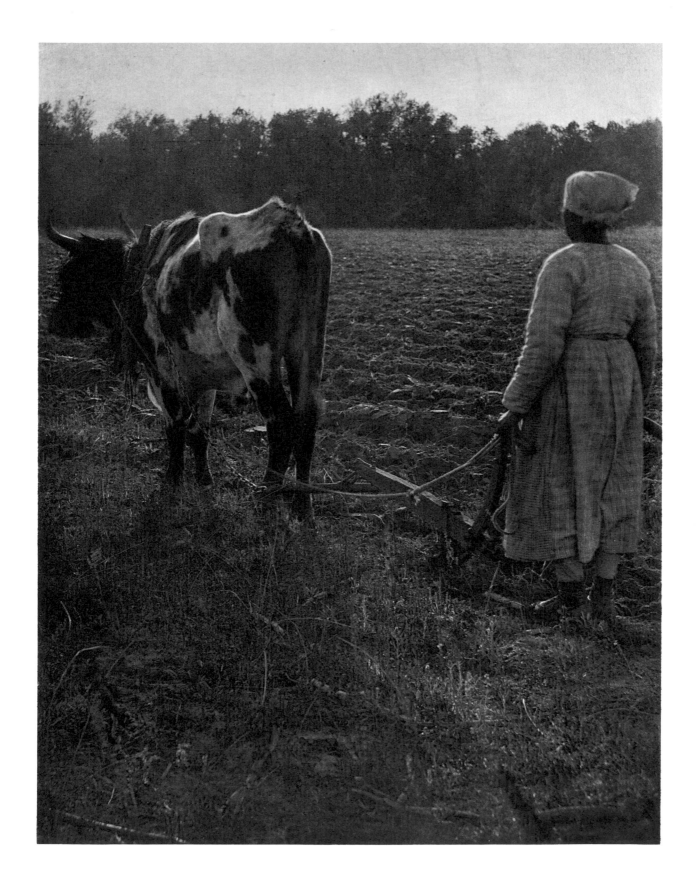

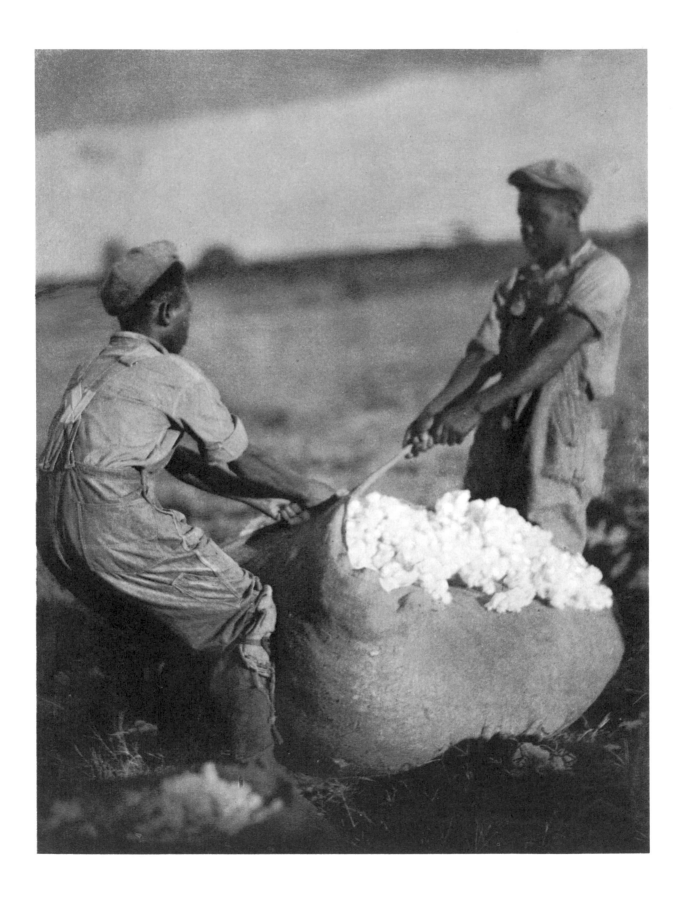

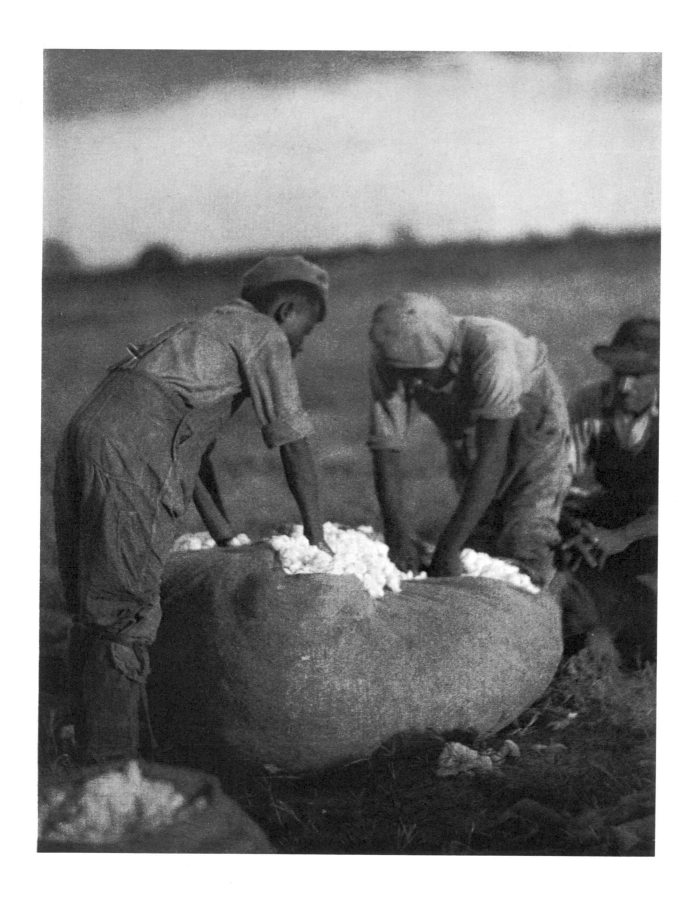

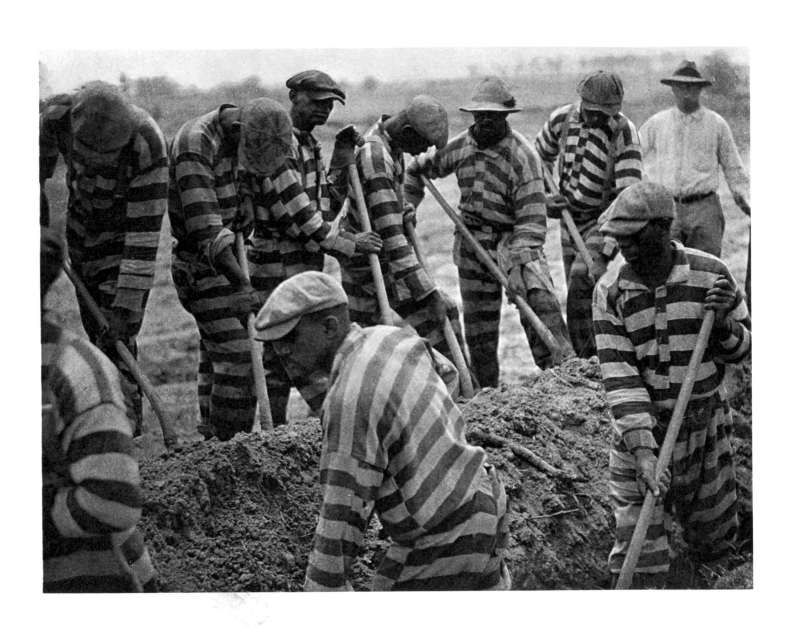

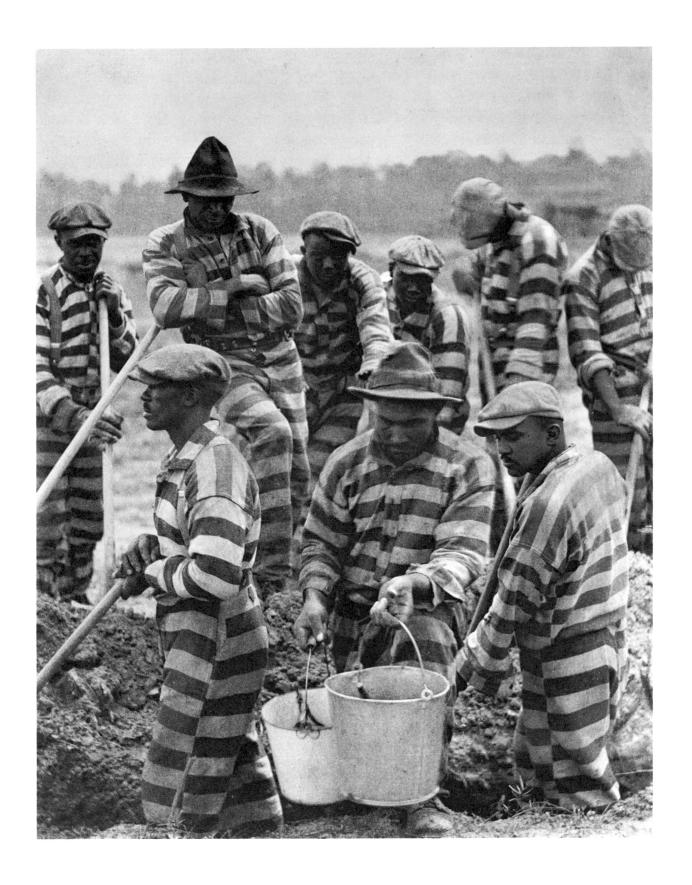

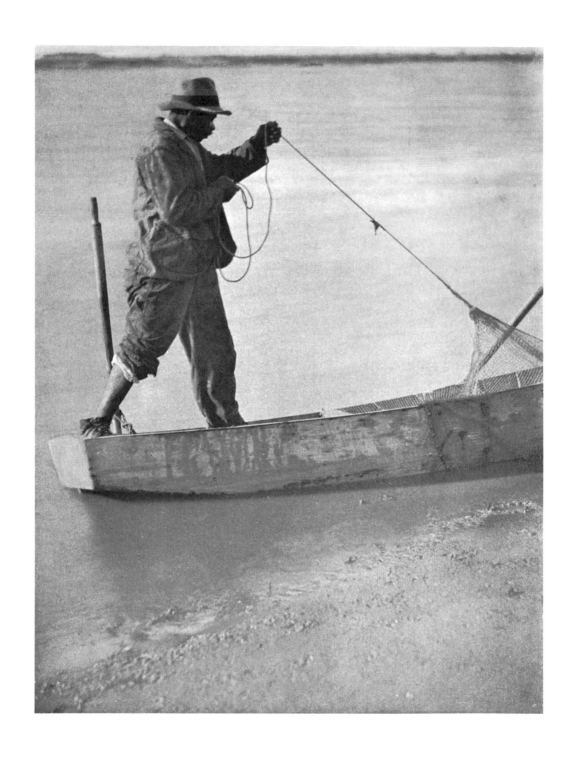

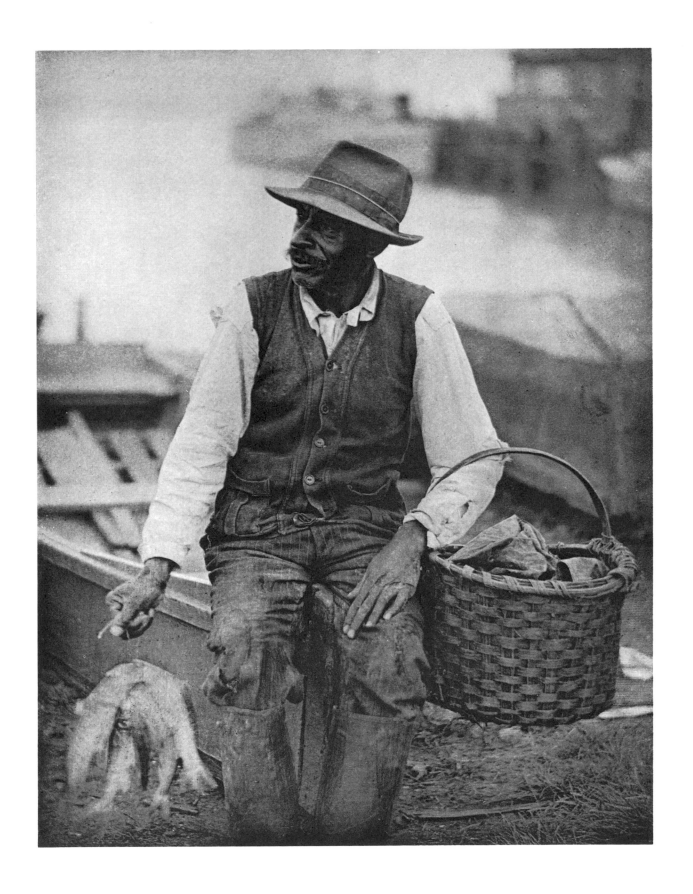

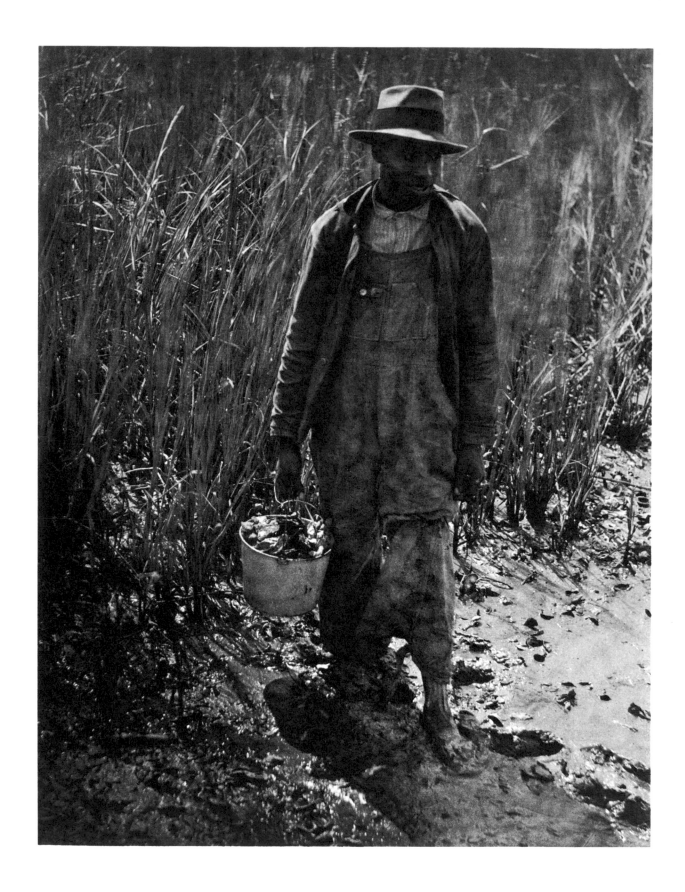

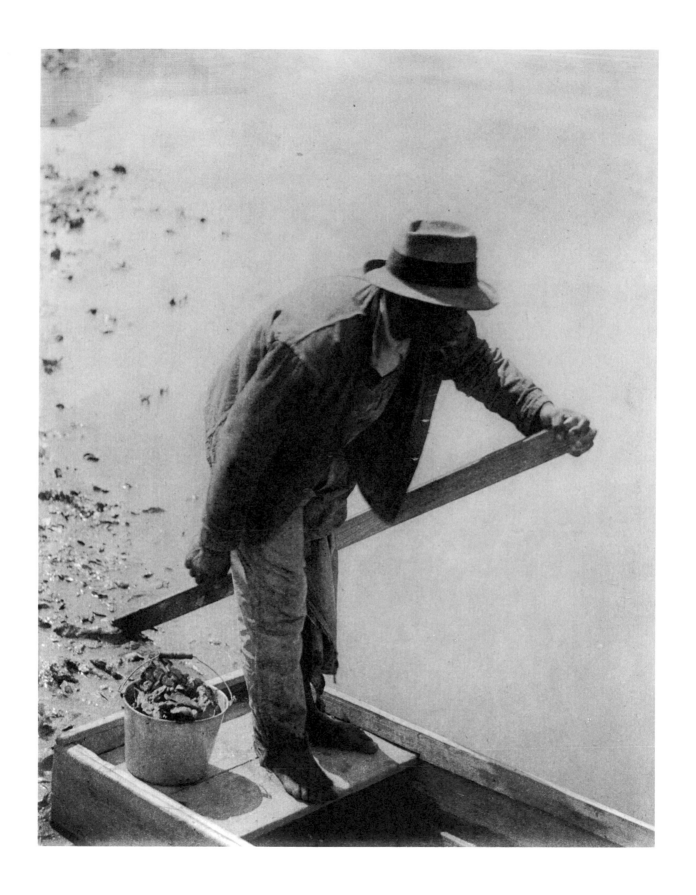

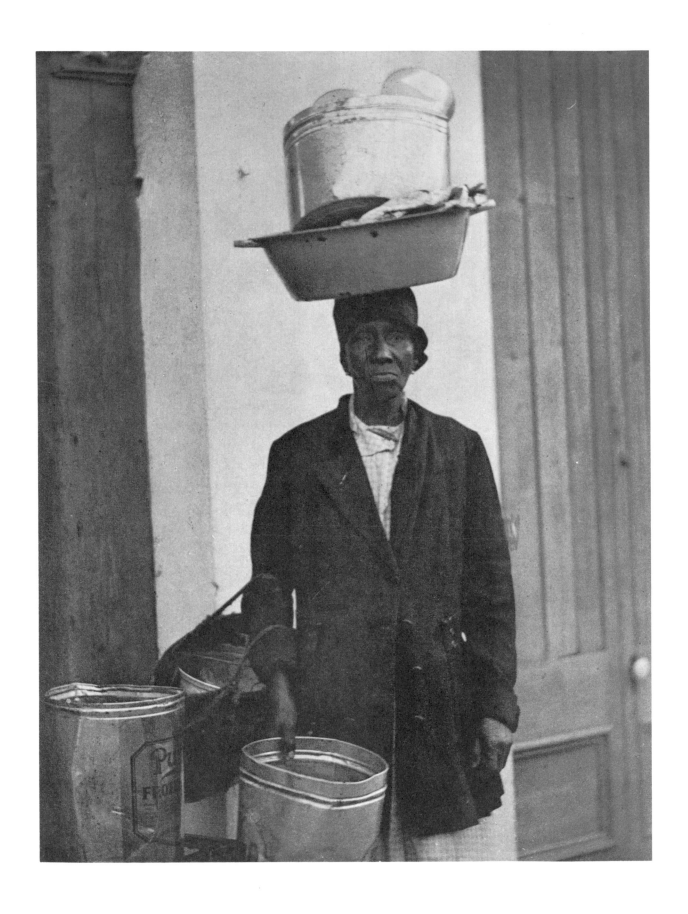

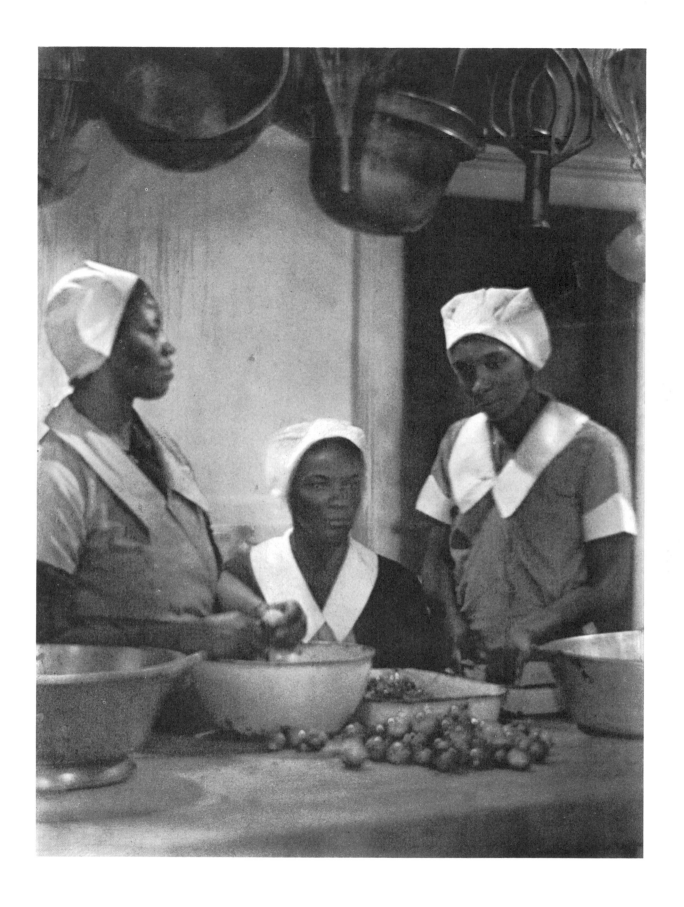

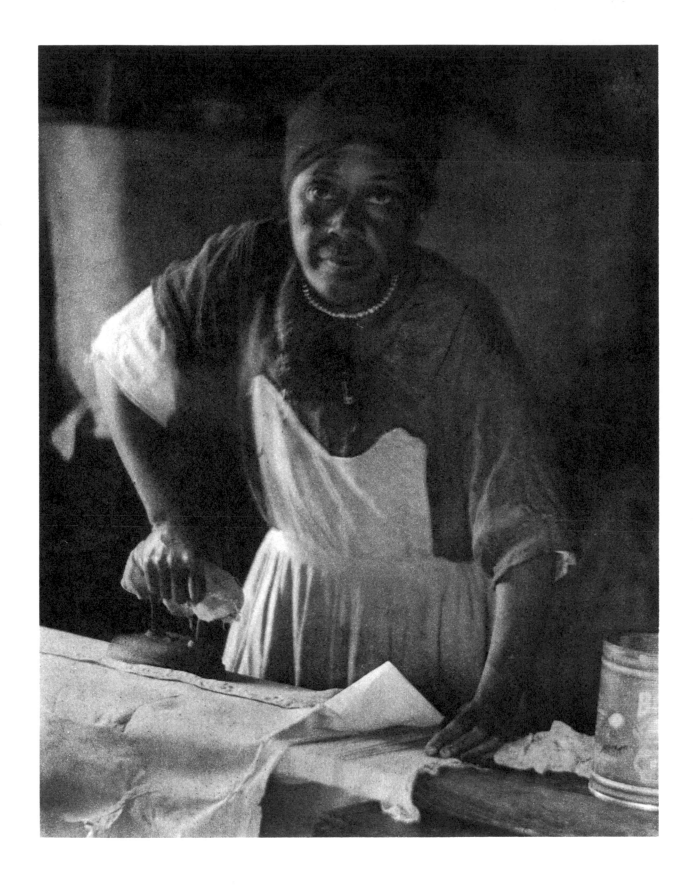

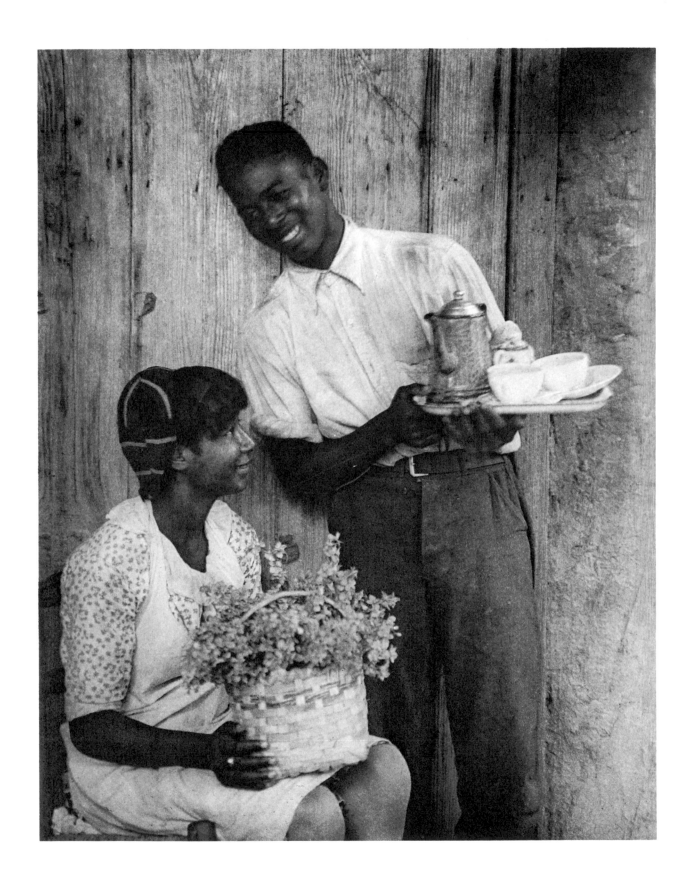

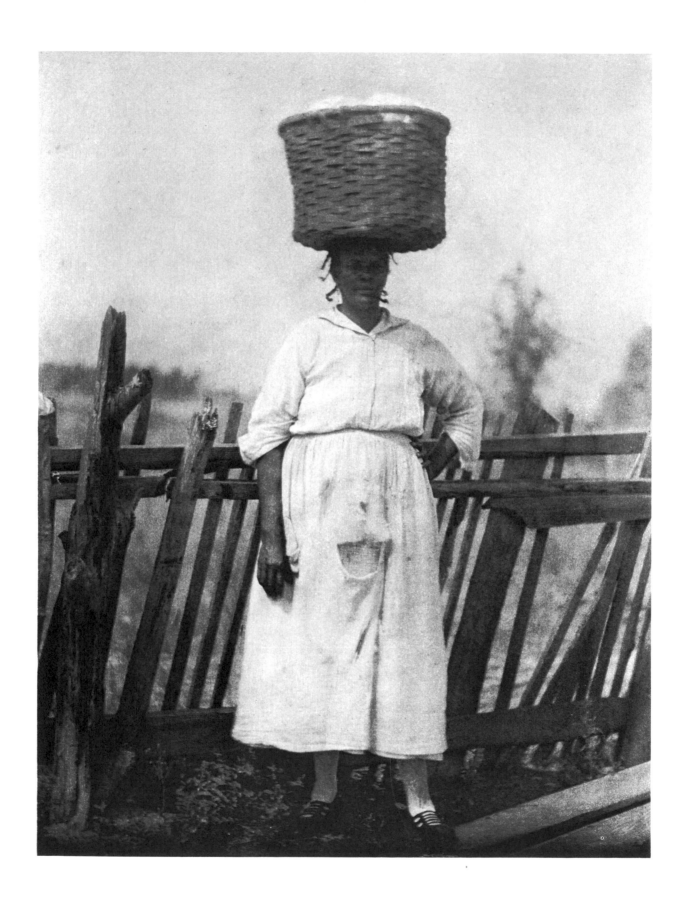

46

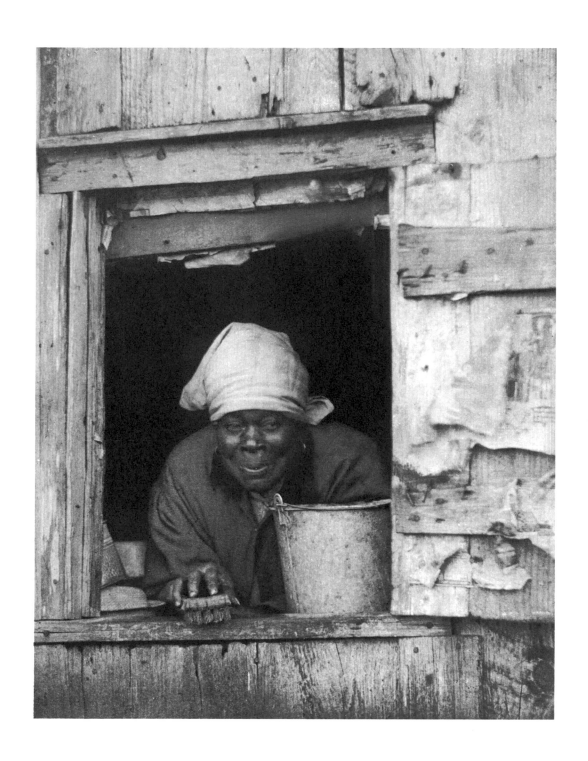

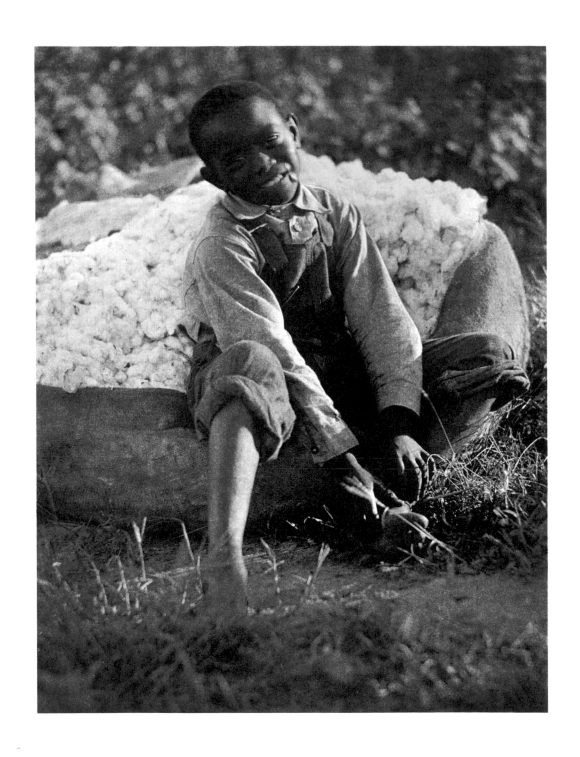

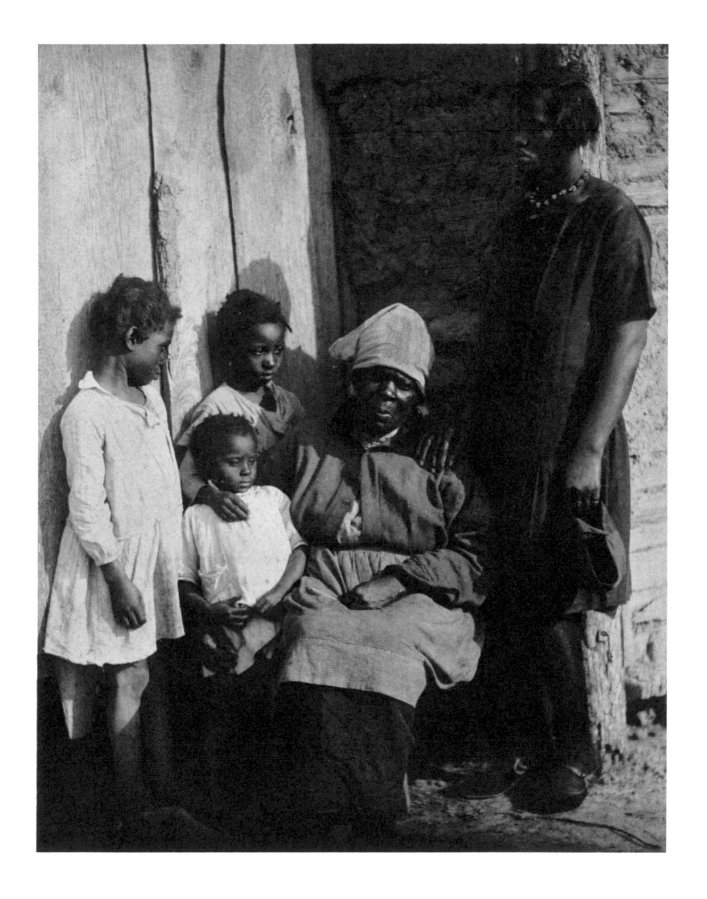

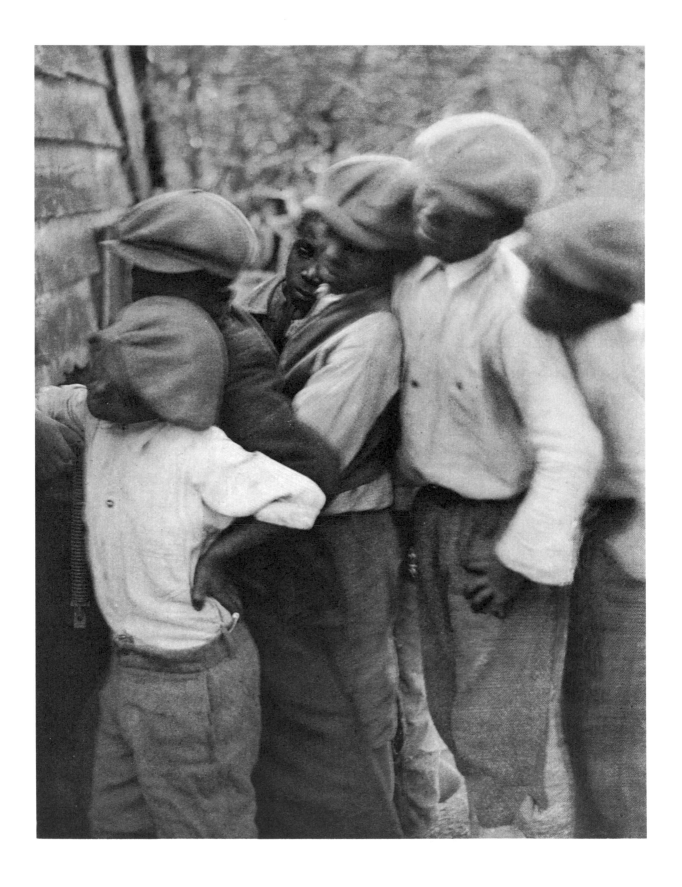

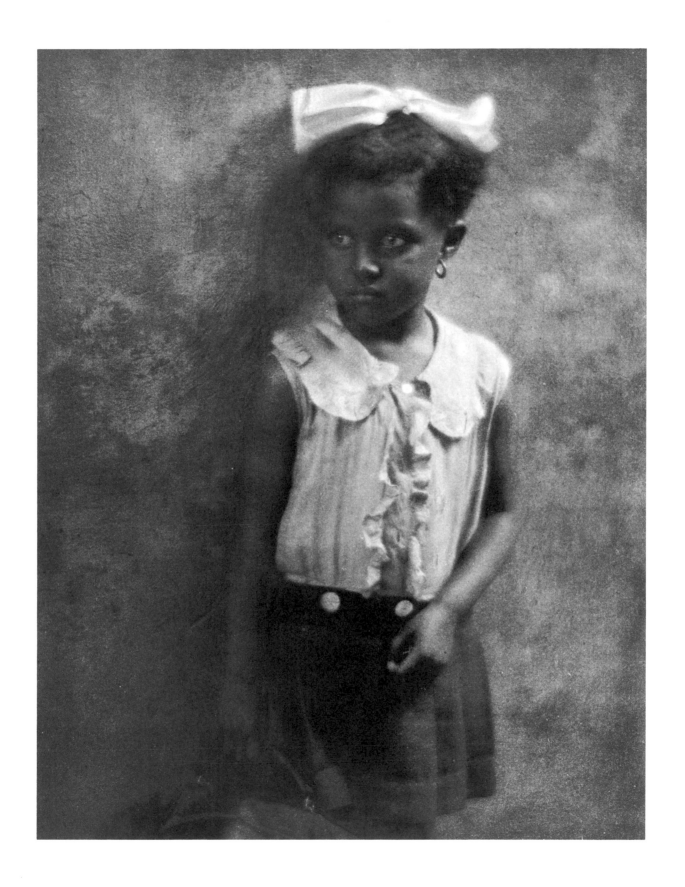

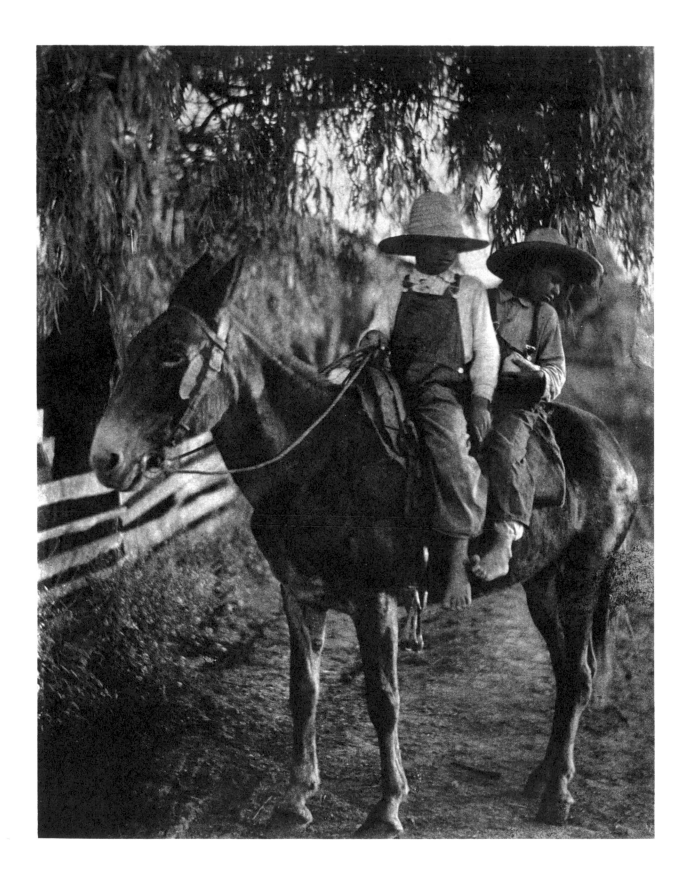

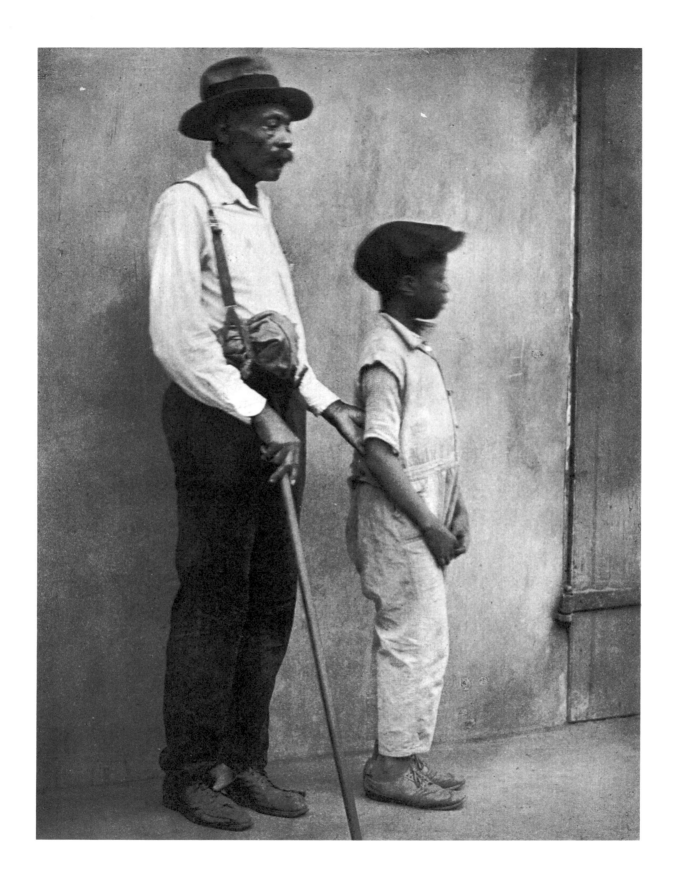

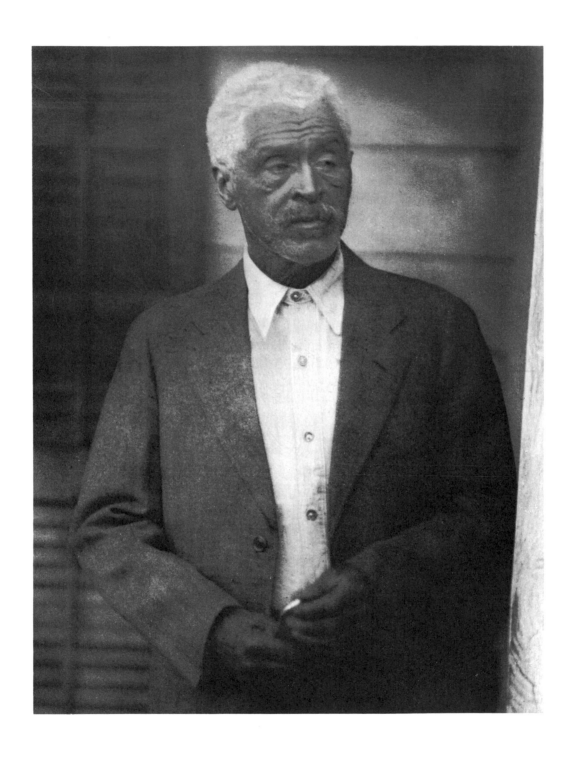

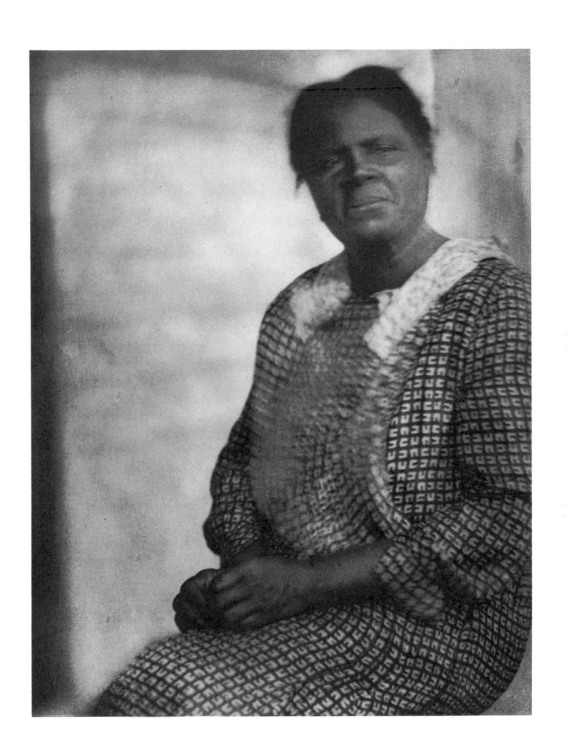

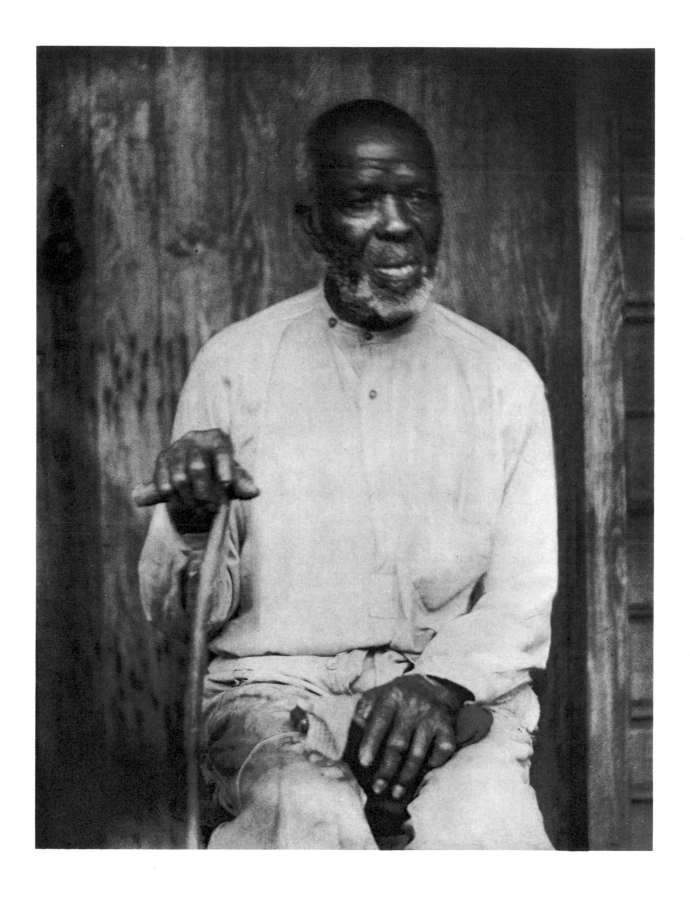

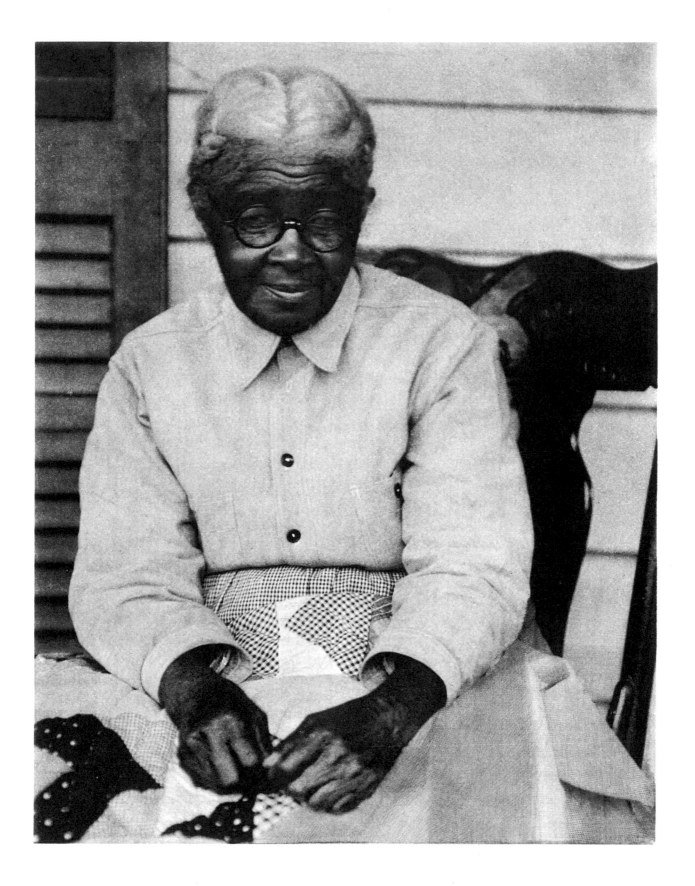

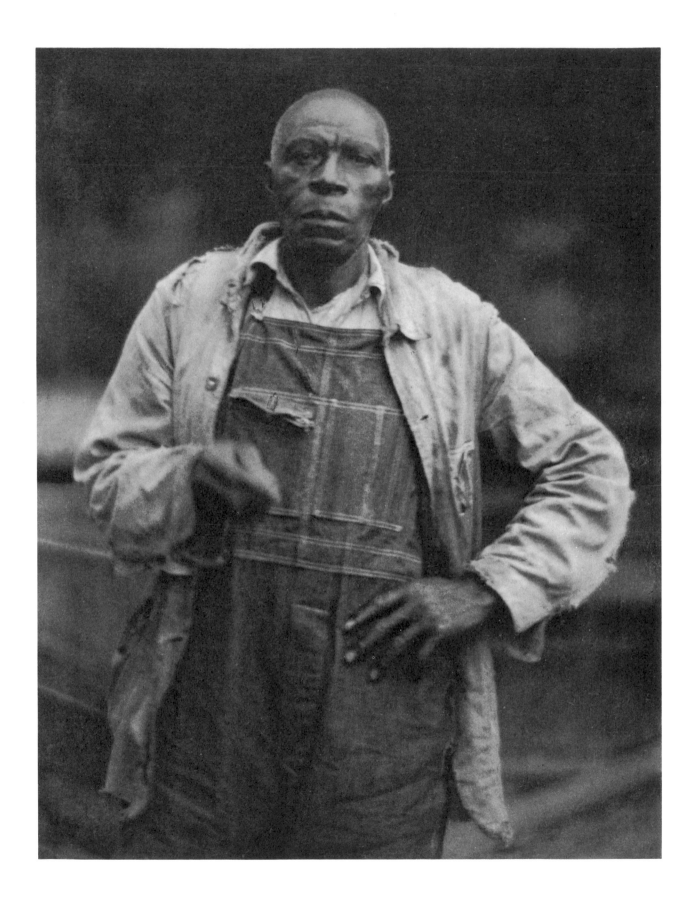

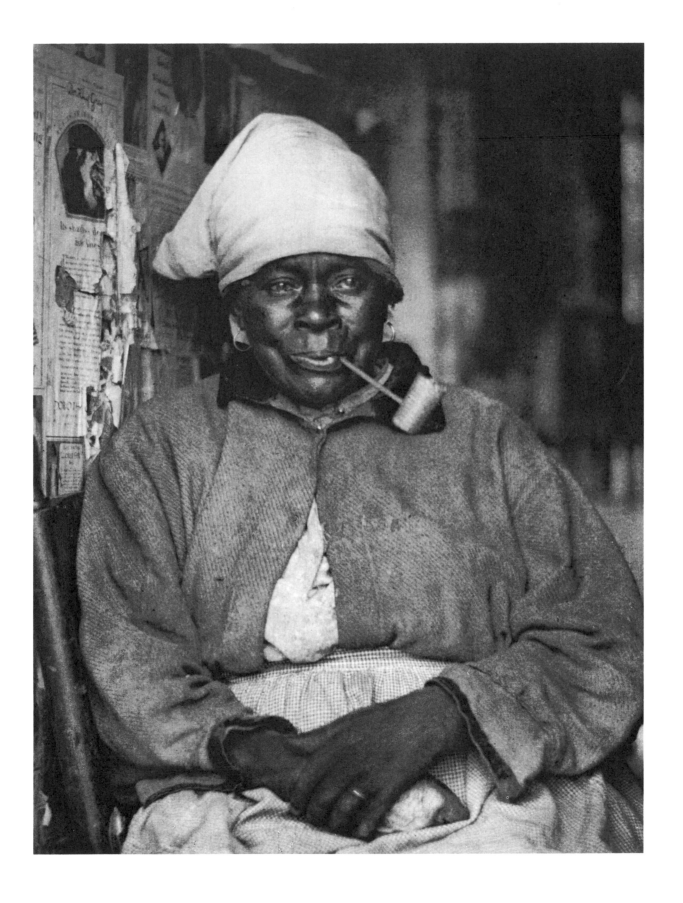

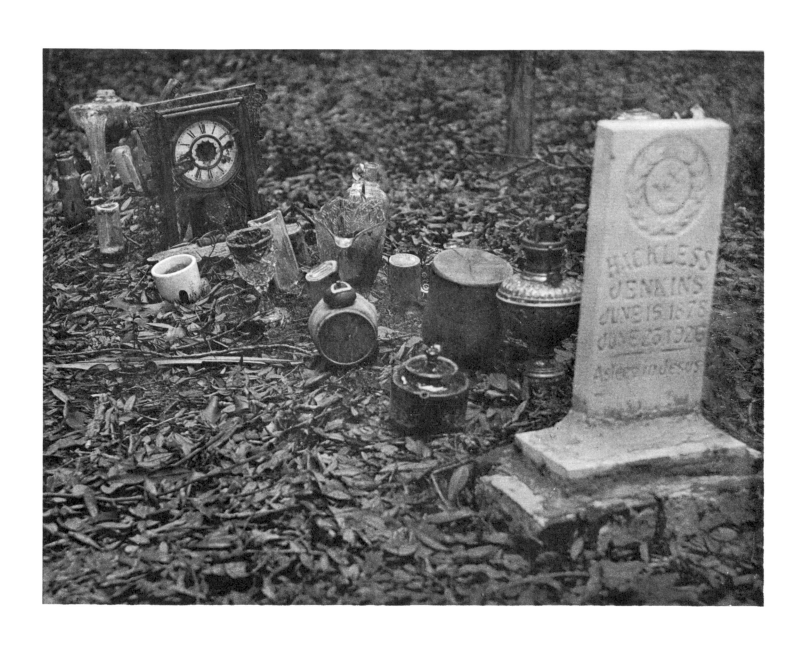

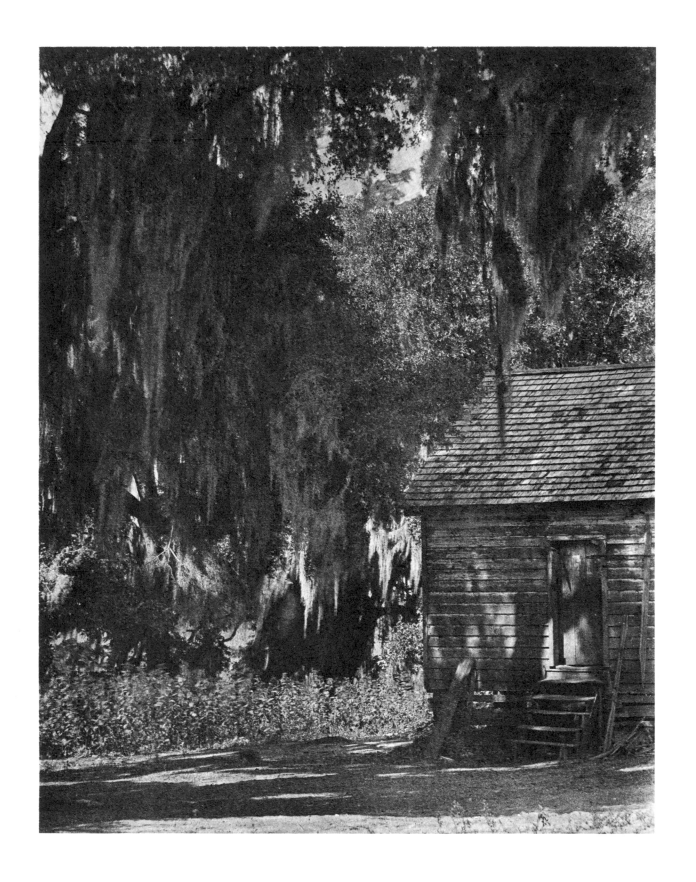

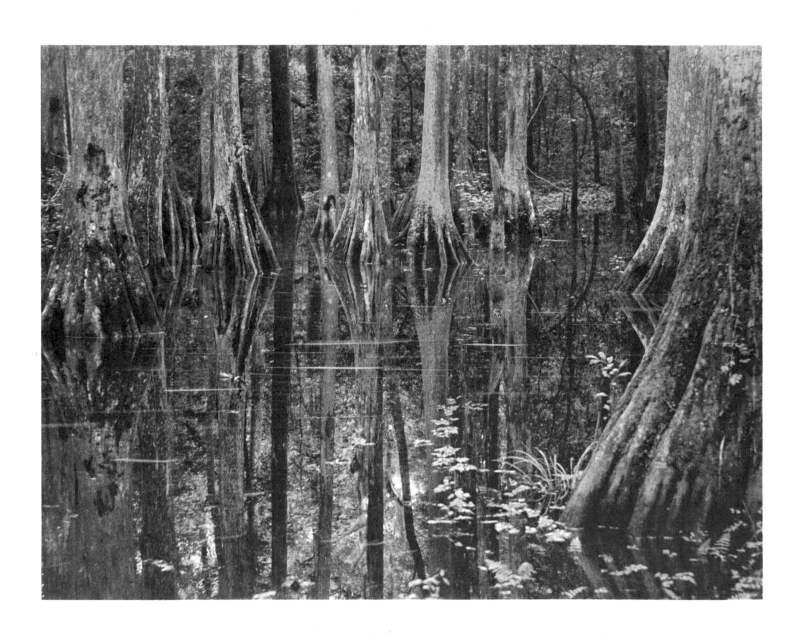

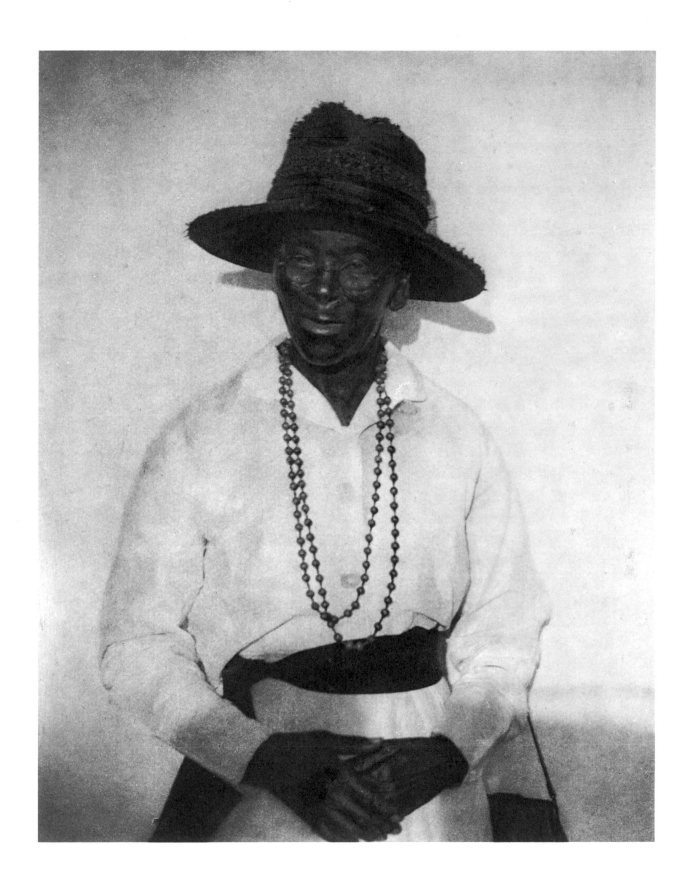

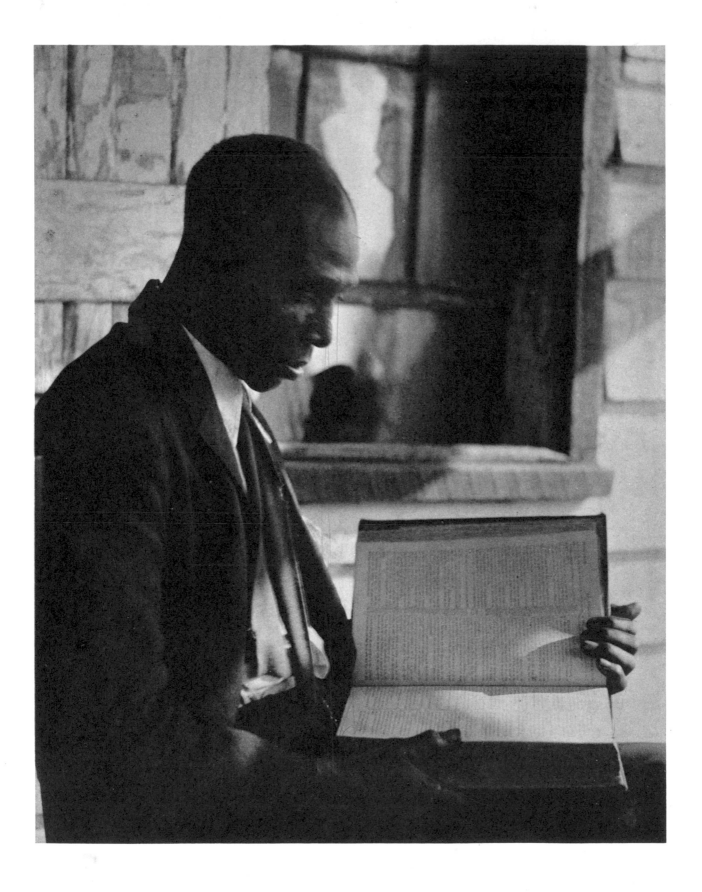

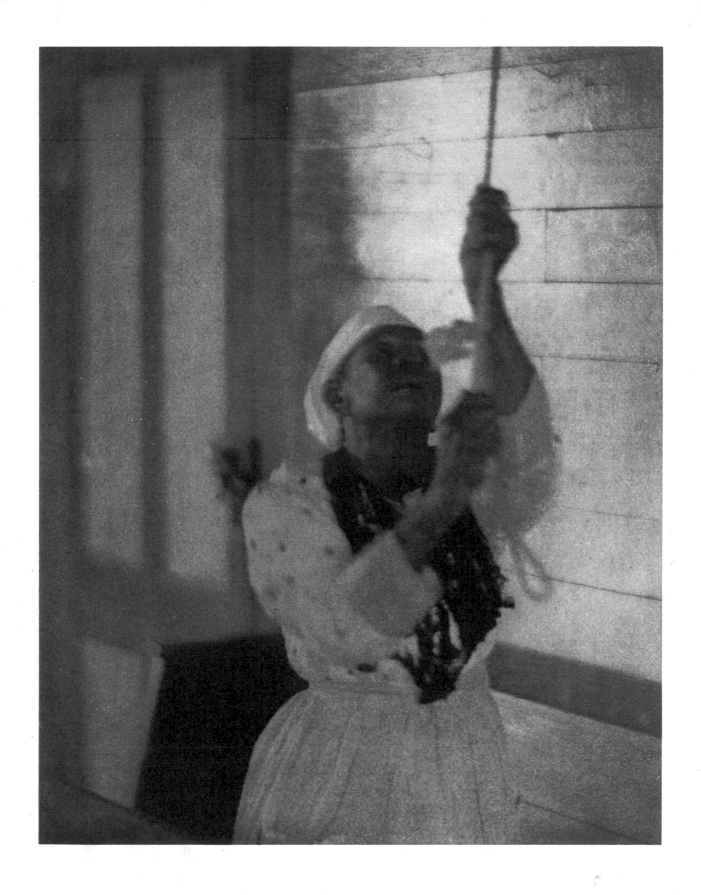

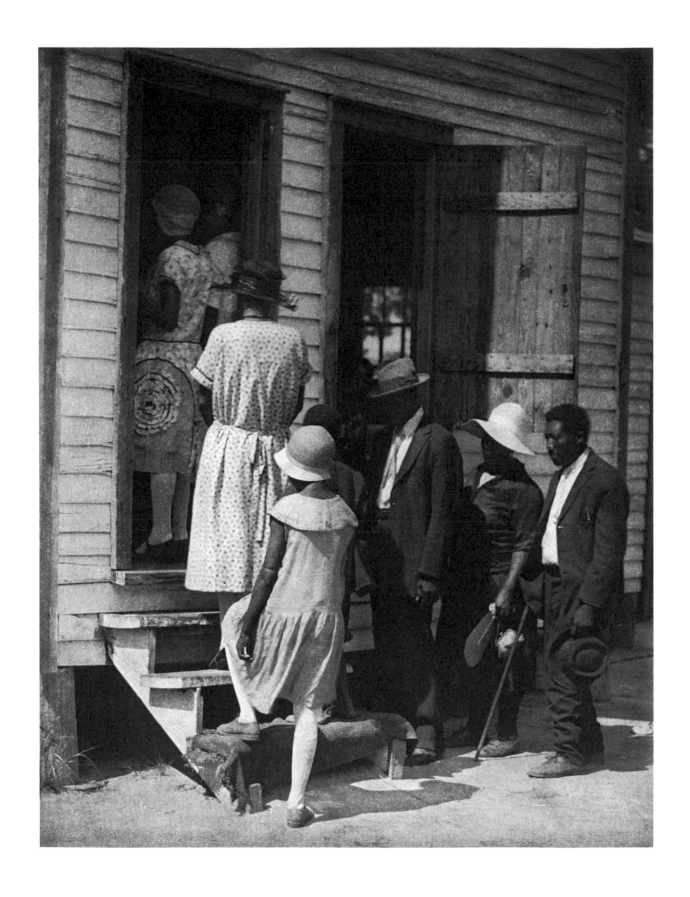

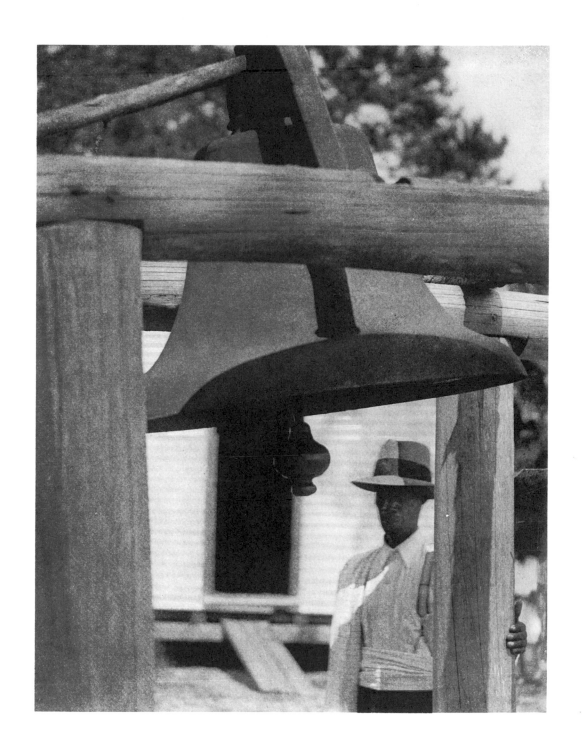

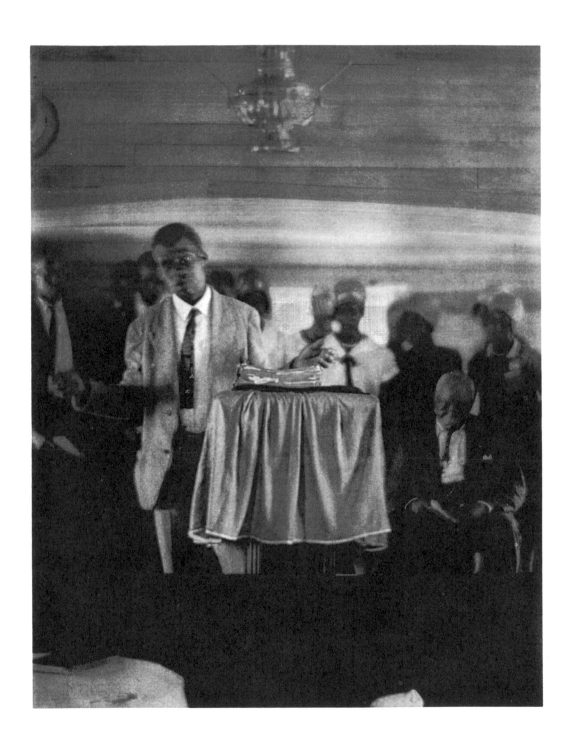

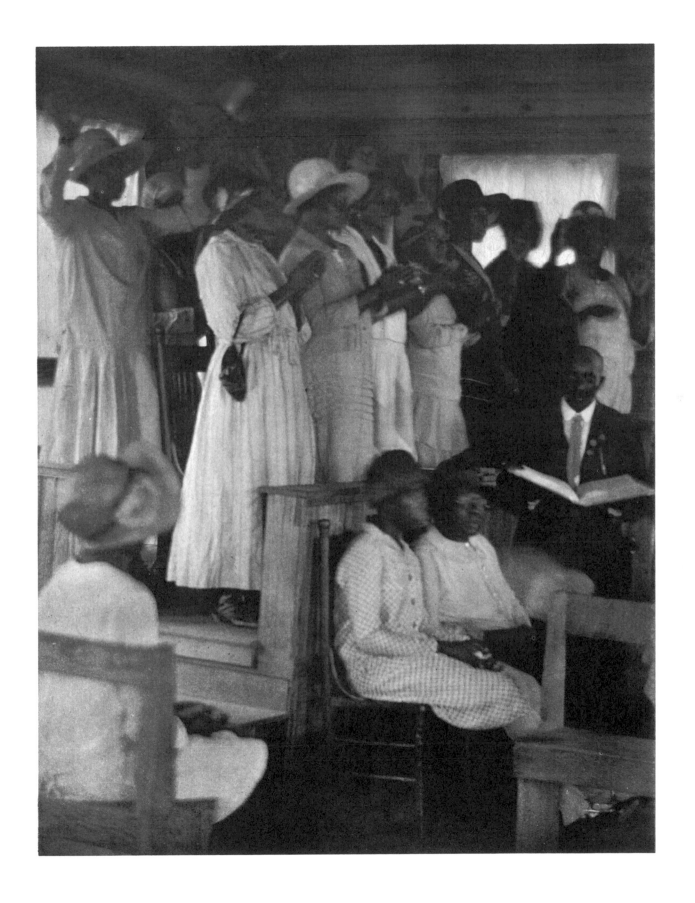

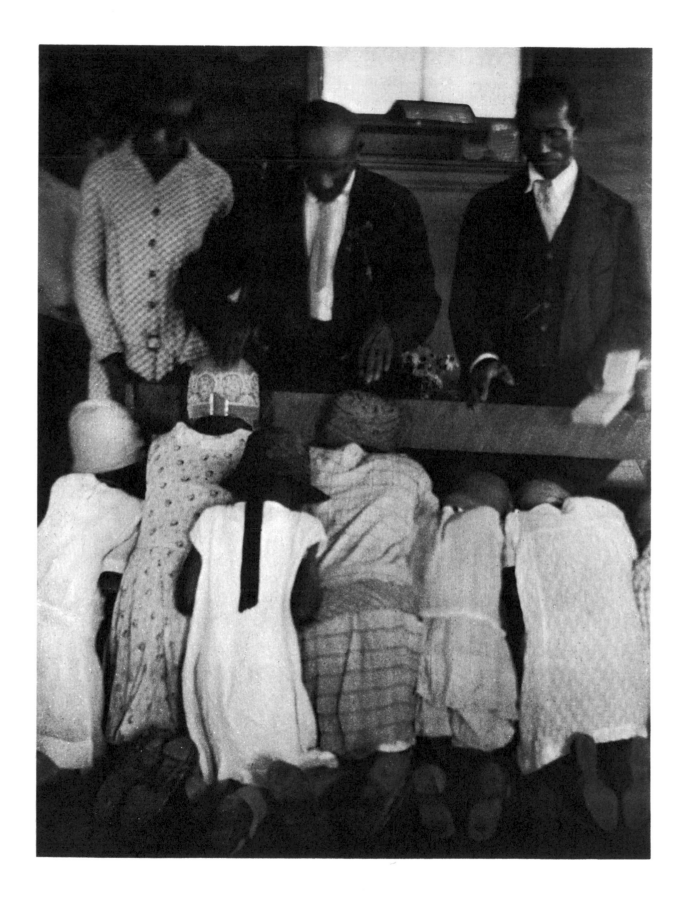

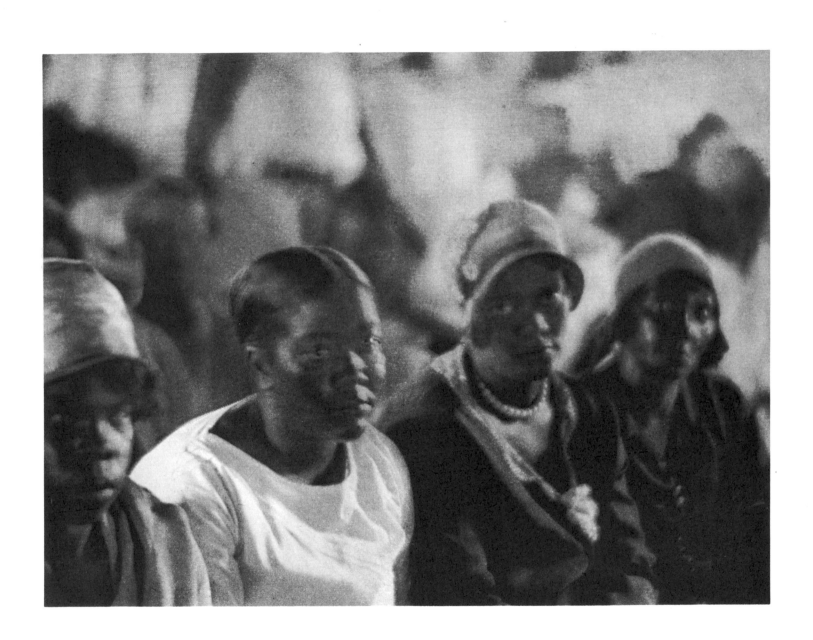

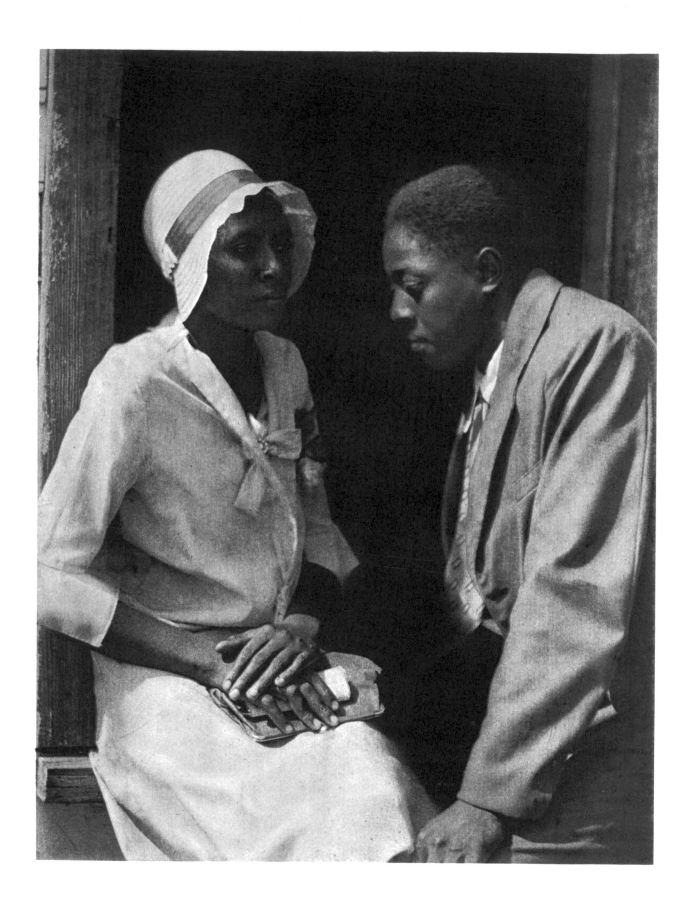

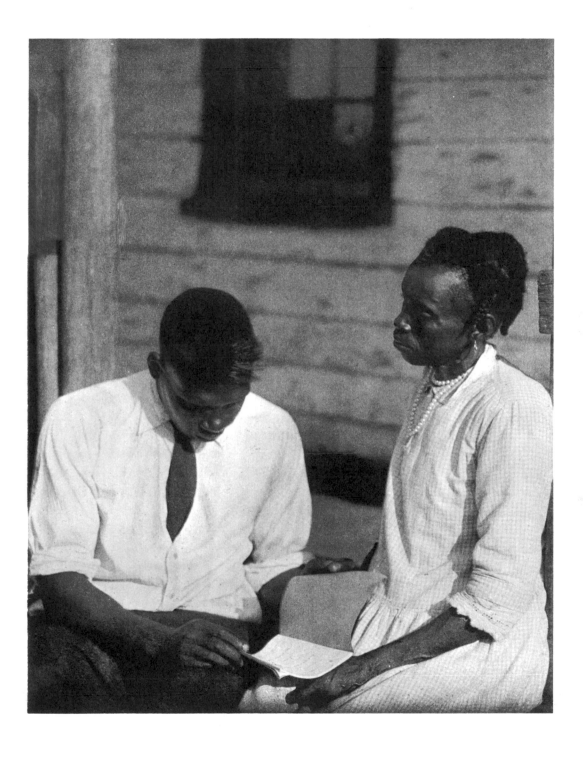

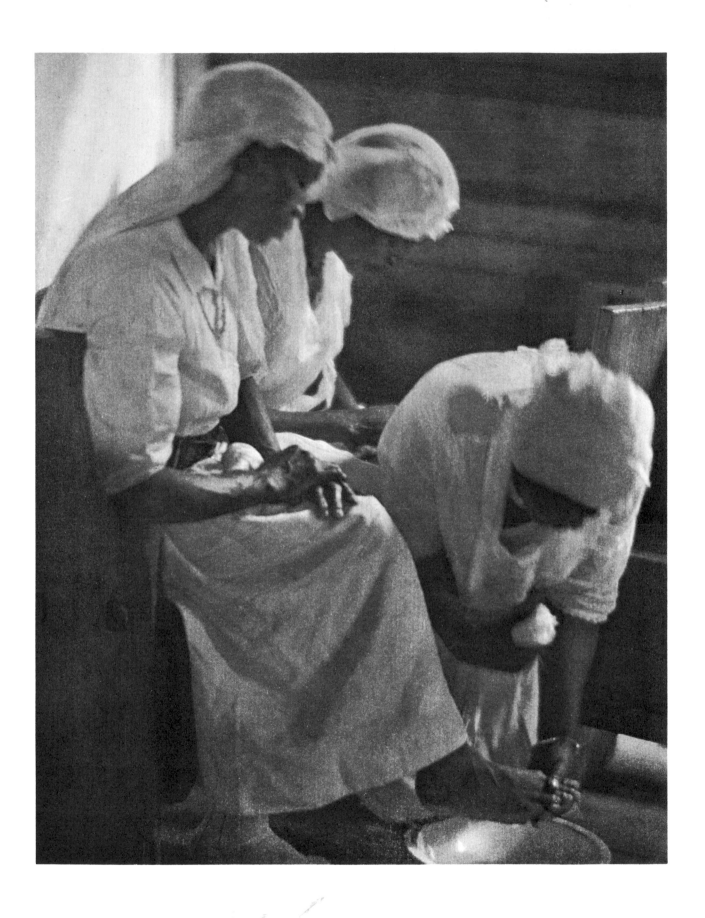

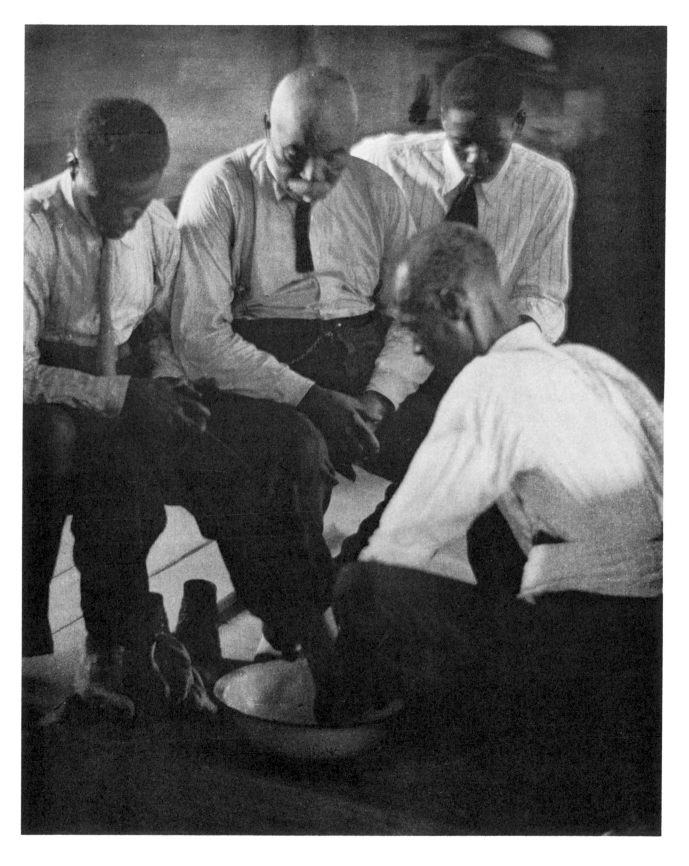

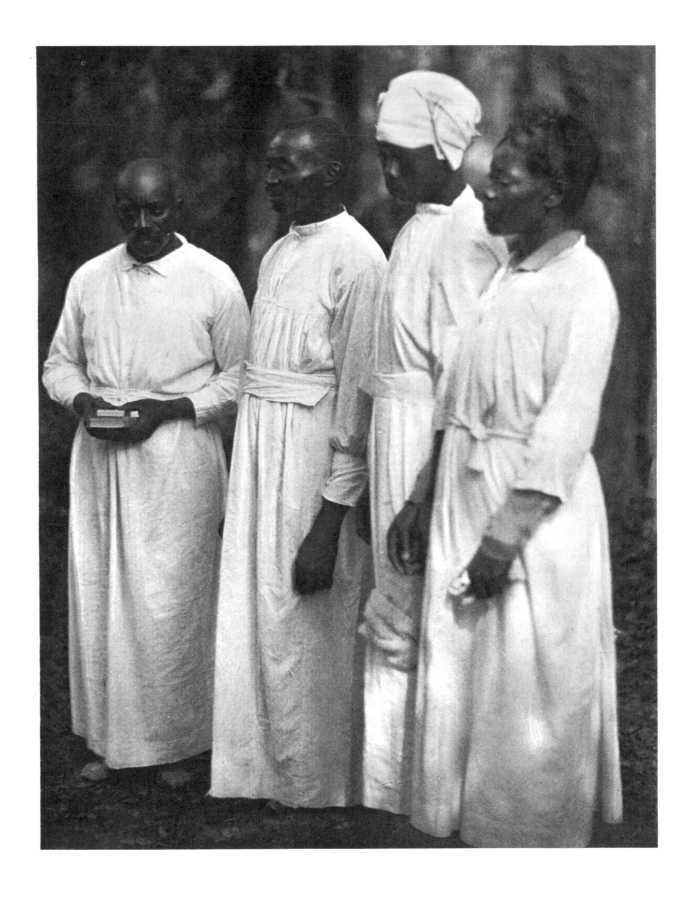

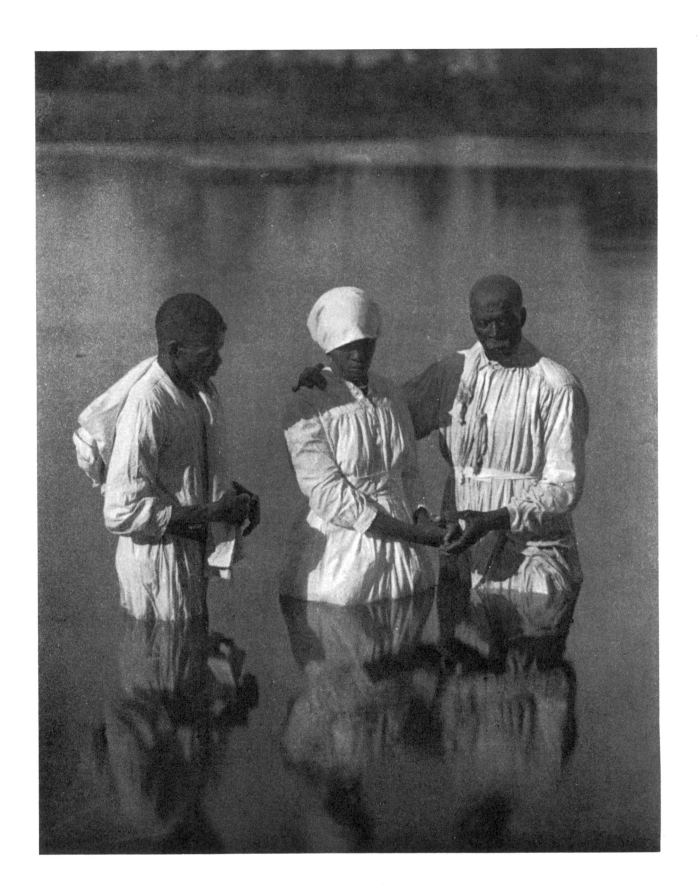

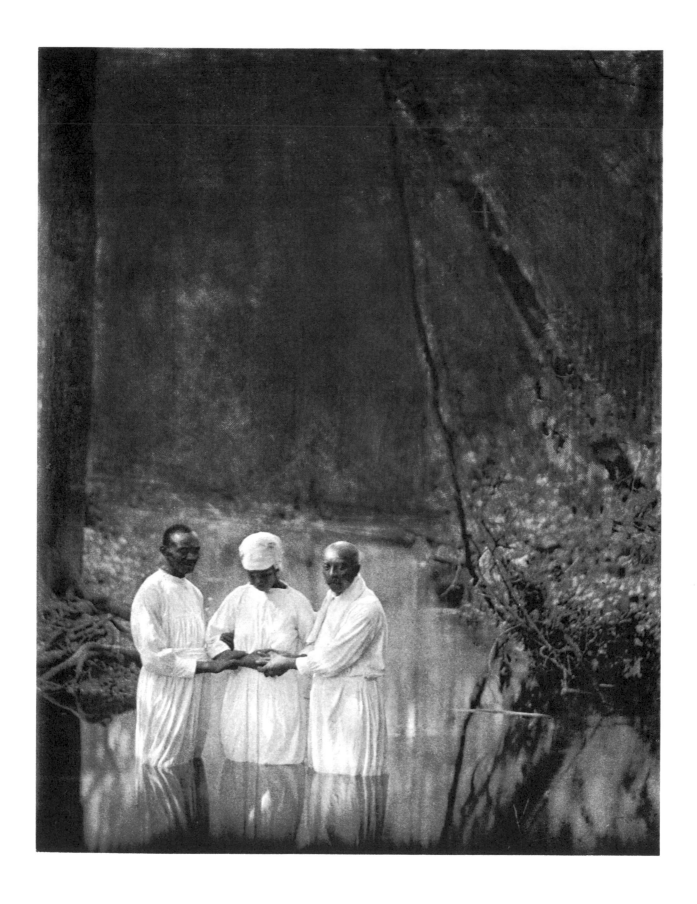

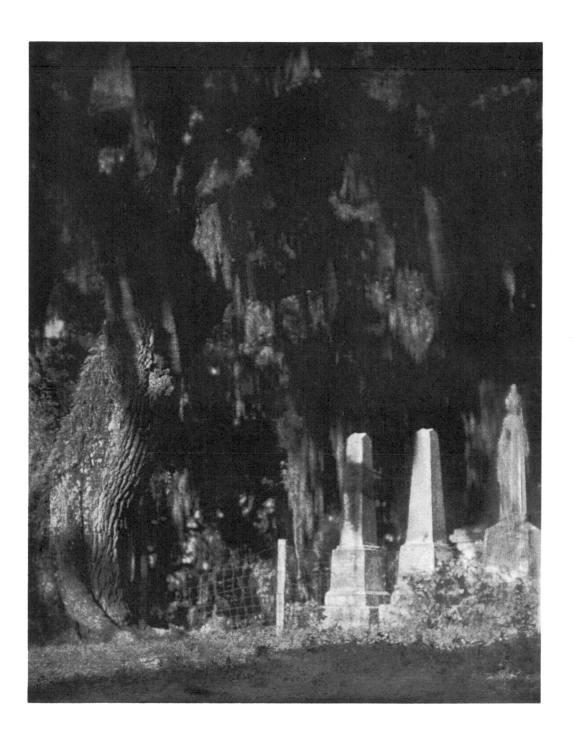

A New Heaven and a New Earth
BY ROBERT COLES

Life's thickness, its more than occasional impenetrability, its complexity that only seems to yield to various formulations (which, in any case, come and go with each generation, never mind century) and finally its sheer persistence in the face of such high and various odds—all of this provokes the scientist to look harder for answers, the theologian to praise the God of Mystery even more fervently, and the rest of us, rather often, to shrug our shoulders and go on to the next moment's activity or obligation. In a sense, then, Doris Ulmann's studies of black people in the rural South, done over forty years ago, in another century really, are of no help at all. Looking at her portraits, one is yet again made to feel confused, uncertain, a bit awed, more than a bit saddened. We crave order and a point of view. Consistency is a virtue, we have heard for years—no doubt because our parents, like us, knew in their bones that the opposite is what obtains universally: the inevitable inconsistencies, the paradoxes and ironies which constantly confront us. Per-

haps some of us will feel cheated as we go through those photographs: Where is the "frame of reference" social scientists have taught us to have? And what is the photographer up to, anyway? (Various ideologues have taught us that she must be up to something.) Is she attempting to romanticize, once again, the dying plantation South, with its mythology of happy "darkies" and gentle "white folks"? Is she trying to lend strength to the message of the agrarian movement, so prominent in the 1930's—that urban life is brutally impersonal and degrading, while in the rural sections of Georgia, Alabama, Louisiana, the Carolinas or Mississippi, for all the poverty and "primitive" living conditions, there is among the people, black and white, rich and not-so-rich and poor, a sense of community, a sense of the self as a particular person whose roots are clear and strongly implanted? Is this what Doris Ulmann wants to evoke in us: a sense of nostalgia, a sense of regret? Or is she the ever so subtle social critic, intent on winning us over to a people and their suffering—to the point that our sympathy and admiration will soon enough turn to moral and political outrage that it is still possible in this rich and mighty land for people to live as these good, decent, God-fearing people must live?

In 1933, when *Roll, Jordan, Roll* was published, the National Association for the Advancement of Colored People gave it enthusiastic approval. One of the organization's leaders, Walter White, found the book a "magnificent achievement." He had in mind not only Doris Ulmann's work but the accompanying text by Julia Peterkin, which many today would no doubt find condescending at best, and perhaps utterly offensive—all that talk of "charm that made the life of the old South glamorous." Yet, three years after *Roll, Jordan, Roll* was published, an extremely knowledgeable writer, out of the cosmopolitan, politically sophisticated and liberal if not radical Manhattan intelligentsia—and how he detested such a side of himself, even as he couldn't get away from it—would go to Alabama and with a photographer friend confront a dilemma not unlike the kind Doris Ulmann and her collaborator must have faced as they tried to comprehend and convey to others how life is lived in a very special segment of this country. James Agee and Walker Evans sought out white tenant farmers rather than black ones, but no matter: they were, like the authors of *Roll, Jordan, Roll,* two well-educated, reasonably well-off social observers, intent on documenting certain specific yet somewhat representative lives for readers by and large like themselves—the upper-middle-class, socially concerned element, most likely intellectuals of sorts, who would buy a book with the title *Let Us Now Praise Famous Men,* especially after having looked at its "subject matter" before making the purchase. Julia Peterkin did not work with Doris Ulmann as Agee did with Evans; she

wrote of Southern blacks out of her own wide and deep awareness of their habits, beliefs, values. But she was after the same truth Miss Ulmann sought—a truth we also, presumably, seek. And it is a truth which justifiably caused James Agee so much anguish and near hysteria, because it is one that has so many versions to it, so many sides, facets, points and counter-points. Moreover, it is not a static truth—not *there*, if difficult to grasp and hold on to.

Agee's "famous men," Evans's obliging and patient "subjects," are today not quite the same; I know from my own work in Alabama how things have changed in that stretch of countryside between Montgomery and Birmingham. The progress of this past decade, as a result of the civil-rights struggle, has also reached into the most obscure and "backward" regions of the Old Confederacy, into towns like Midnight and Louise, Mississippi, like Opp, Alabama, and Quitman, Georgia, and Bolton, North Carolina. I do not say that an alert and industrious photographer could not, in 1974, find scenes very much like those Doris Ulmann captured in the early 1930's. On the contrary, a good deal shown in Miss Ulmann's photographs is still very much part of a way of life by no means ended: the work with the land; the loyal and sometimes fiercely proclaimed allegiance to the Christian faith; the folkways which strike outsiders as quaint or all too relaxed or peculiar indeed—clothes worn, food preferred, music listened to, mannerisms of speech, an almost uncanny mixture of the formal and the casual. Nor is it easy to separate black from white customs. Though various forms of segregation have yet to die in many counties of the region, federal laws notwithstanding, the black man in America, as Ralph Ellison has pointed out so many times, is either a Southerner by birth and living or at the very least a Southerner by descent—social and cultural as well as geographical. And since black people have raised so many white people, since there has been such intimacy between the races, such mutual dependence, for all the exploitation and hatred, there has, in fact, been a shared tradition: black and white together, so far as any number of assumptions go, be they tied to the rhythm of everyday life or those larger social and philosophical issues that get called a "world-view."

To make my remarks concrete—and, I would think, infinitely more valuable—I have to call upon some black people I have worked with, men and women of the small-town, still heavily agricultural South. Again, they are not today completely similar to the people Doris Ulmann shows us in the book (though many, born about the time the children she presents, are obviously still very much alive, however changed by history's various twists). They are, however, in certain respects very much like their ancestors, even as we

all, hopefully, carry with us important parts of our heritage: a turn of phrase, a point of view, a memory of an attitude expressed, which in sum give us our particular character or cast of mind. Perhaps what is so fine about Miss Ulmann's pictures, apart from their somewhat haunting and mystery-laden quality, their gentle, luminous and suggestive reflection of a particular kind of life, is a certain timelessness she has managed to capture. For all the specifics we are given, there is an almost otherworldly aura to her camera's creations; it is so much, and so ironically, the light she has an eye for, the shadows, the shades of the day's truth, literally as well as figuratively. Haziness, duskiness, a moment of glow, the alternations of a veil and a burst of sunshine—these, I would think, are Miss Ulmann's obsessions. She saw the confusions about her, and tried to give them to us as candidly as possible: the darkness and the light in several senses of those words. Black people have always been part white (one refers, here, not only to genes) even as whites are so very much black, as anyone who has spent time in a small Southern town eventually gets to know.

These photographs come closer to more truths than perhaps anyone's words can evoke, though again it seems fair to let a few individuals try. A black woman, for example, from the eastern shore of North Carolina, still heavily tobacco and cotton country: "I'm thirty-four, but I sometimes feel like I'm twenty-one, and I sometimes feel like I'm going on one hundred. I have my own family, and I have his—the bossman's. The bossman's wife, she'll say to me, 'What would we do without you,' but she doesn't really mean she couldn't get along if I'd suddenly go to meet my Maker. He's a lawyer, and they've got plenty of money. They'd hire someone else. When she wants to be real nice she tells me how we're both the same, children of the Lord. I say, Yes ma'am. What else can I say? I believe she's right; I'm her right arm, and I can tell what she wants done in that house of hers before she knows herself. We sure are children together, and I know the Lord is watching. Don't ask me what He's decided, though. I can't figure out myself what's going on. I'll be cooking for them and hear them talk about how nice I am, my good food, and then they'll turn on all the colored because they've seen something on their television. If I come in the room it doesn't bother them. I'm *theirs*, I guess, one of their own people. That's how they think about every colored person around here: we're property of theirs, even if there's no more slavery. It's the ones up North they don't like: full of sass, and uppity as can be.

"Well, I know how they feel. We have a cousin, my husband's, who went up there, to New York City, and he comes back here once a year on his visits. A regular big shot.

He's throwing his dollar bills around, and pulling on his suspenders. He says he's a fore-man or something. He'll ask me how I'm doing, and I'll say fine, and then he says no, I'm not doing fine; *he* is. So I say nothing. I let him have his fun. He comes each year with a big new car, and all he's doing is standing beside it, as long as he's here, calling people over—especially the children, because they don't know better, they don't have his num-ber—to look inside his car. And if you don't say 'Lord, that's wonderful,' and 'Lord, it's the most beautiful thing ever made in the whole wide world,' then he'll be pouting and getting fresh and threatening to go back home. I always wish he would, of course, the sooner the better, but his mother, my husband's aunt, she just thinks that man is the President of the United States, and no one less big. So we button our lips and count the days—two weeks every summer. By the end of that time, I'm cussing to myself like the bossman and his wife: those Northern niggers.''

 She pauses to think. As she sits on a chair, her hands folded, her face cast slightly down, her eyes sometimes looking at her visitor, sometimes down at the floor of the cab-in, one can imagine Doris Ulmann in that room, anxious to get rid of all distractions, to catch in a second some utter essence of a person—and more, the essence of one neigh-borhood after another. The woman herself sometimes has the same desire: ''I look about—it'll be a slow time of day for me—and I start wondering to myself why I've been put here by the Lord. I'll go to that mirror we have, and look at myself, and I even talk to myself: Oh, Annie, I'll say, just look at you, tired as can be, and still she'll be wanting you back in that kitchen of hers, because there's company coming and you've got to cook this and cook the next thing, all the preparing. Then they'll come, her company, and they'll tell her she's a wonderful cook, the missus is, and how does she do it, with all her clubs and her charities and her children to look after and the grandchildren now coming along. Of course, I always smile when I hear them praise her. I'm glad I've done her a good job. I'm pleased as can be that good white folks know what's good cooking, real good cooking. I only wish my own family could taste some of that food. I only wish they knew what I can cook up with those electric machines she has, her blender and her cut-ting knife and her two stoves, not just one, and her freezer that's as big as my whole house, practically: all that food they've got put away—enough to feed the whole conti-nent of Africa, I'll bet. That's the kind of thing my head pulls on me during my off hours. I'll recollect the work I've done and the work around me, and I'll have to admit, I'll catch myself feeling sorry for myself every once in a while. But then I whisper *hush* to myself, and I'm just grateful to the Lord, for giving me a little time here on this earth of His.''

There is no more for a while. She is silent out of reflection. The sight of one of her children causes her to smile, and the child knows not to speak: it is another moment Doris Ulmann would seize—the child's mixture of reverence, respect and intimidation all come across in a face both mobile and for a brief spell fixed. Then the child leaves, and the mother prepares for her own departure to "the big house." She can speak awhile, because there is yet no hurry: "It's no joy saying goodbye to your own, so as to take care of someone else's. They'll hand me their grandchildren, and would you believe it, hardly five minutes have gone by since the little ones have been brought over. Like toys, children are to the white folks—so long as they've got a colored maid around. My grandmother, she had more patience than I do. My mother, too; she would tell me not to question, not to ask all those whys I used to push on her. 'It's God's design,' that's what I'd hear. My father, he was a preacher, you know. He wasn't a minister, not a man who went to school; he was just someone who took that Bible so seriously, he memorized it. He couldn't hardly read too well, but he could recite to you, because he could remember what he'd heard. And if I started saying something isn't fair, he'd say that was for the Lord and no one else to decide.

"I know better now, I'll have to say it. Daddy's quite old, and in front of him I mind my tongue, just like he brought me up to do. But I know better. I'd catch sight of the civil-rights people on their television, and I knew what was coming: they'd ask me if *I* went along with 'all that.' (They'd call the demonstrations 'all that.') So I'd oblige them and say, No sir and No ma'am. And there wasn't anything else to do but go back to cooking, or the sewing she gives me. My mother sewed for them, and my grandmother, and now it's my turn. But I'll tell you, I only have one daughter, the rest sons. I lost two of my daughters before they were born. My girl won't sew for them. I'm the last of the line. My girl, she thought Martin Luther King was Jesus Christ. When he died, when they shot him, my girl said he wasn't killed, he was crucified. I told her to stop saying that word so loud. I told her the next thing the minister would hear her, and then she'd be in real bad trouble and there wouldn't be anything her father, nor me, could do about it. So she stopped. But she's only ten. When she's fifteen, I know it, she'll have her own ideas, and there won't be any use talking to her. That's how it is; the Lord has the old and the young, and us in between, and He gives us each our ideas."

Her old mother is sitting on the porch, and she looks at her, and it is as if she has suddenly become Doris Ulmann's camera. Not only does she take her mother's measure; she depicts her, represents her, realizes her. She begins to stoop a bit, she folds her arms and

rests them on her lap, and she seems more detached, more resigned to God's will, to fate, to whatever it is that controls our destiny. But she is not her mother; the life in her fights against the adjustments if not the surrender that age exacts: "I'll go with my mother to church, and for most of the time I'm just like her—ready to accept the minister's words. My daddy taught us to listen and obey. My mother listened to him and obeyed, and so did we. But my children will be moving about; they can't stay still as long as the older people do. Suddenly, the bug will get them and me as well. I feel like running out of the church and shouting something. But don't ask me what; I don't know. Once I asked myself what I'd say, if I was out there in the field, running from church. I couldn't come up with an answer. It's like with the crops: when we were little we'd try to help with the harvesting, even then, but we couldn't stand still and pick—not any more than we could sit still and pray. My mother, she can still lean over and pick better than I can. My back seems to be saying, Stop bending me. My back isn't as tame as my mother's. You have your good, old horses, trained they are. You have your horses that know how to do their work, but they're likely to have their independent streak; they'll try to buck you, and turn their back on you, and huff and puff and whine, to make you upset. But they go along. Then there are the young ones—the colts who haven't learned what's expected of them. I don't want to be old just yet. But when I'm real tired I look at my mother or my father and I wonder how they've lasted so long—all the work, and all the tiredness they've known. I wouldn't dare ask my father, though. He'd tell me: It's not *me* who's lasted; it's been the Lord pushing me along, and you don't but obey Him."

The Lord: so often He comes up in the conversation. He is there, very much near, in a way hard to put in words; maybe Doris Ulmann has done the best, the only job possible, so far as His presence goes. It can be said that all her photographs are religious, indicating the many ways that a people of faith show reverence to God—through their work, their devotion to the very young or very old, their appearance and bearing. If these are oppressed people, they are also, by their own insistence, people humble out of a fervent belief in God. They have consecrated themselves to the gift He has given them: time on this earth. Or is such talk sheer nonsense, the mumbo jumbo that the rich and powerful are only too happy to have the weak and vulnerable, the very low and near indigent, keep telling themselves? Is such talk the "opiate of the people" Marx and Engels mentioned? If so, one has to call Miss Ulmann's "subjects," and their descendants, who are indeed still to be met all over the rural South, persistently benighted, saddled with illusions that simply won't go away. And if so, the wisdom and intelligence and virtue of

such people, so often acknowledged by political activists under different circumstances, comes into the most severe kind of question. In the years I spent working with share-croppers and tenant farmers, again and again I met "community organizers" who made such a strong (and I believe valid) point of emphasizing the right of the poor to speak for themselves, have their own ideas of what they want. "Let the community talk," one heard so often. "Let the community decide its own priorities," one also heard. All of us were "outsiders," not only white middle-class Northerners, but black civil-rights leaders from the South—or so we told each other. We were there to respond to various communities, heed *their* will.

Of course, I simplify the matter, even as we did at the time. There is no easy answer to the various dilemmas a movement bent on social and political change can generate—among those to be "helped" as well as those doing the "helping." I remember many all-night "soul sessions" when I worked with SNCC and CORE before, during and after the Mississippi Summer Project of 1964. What *were* our purposes, we asked so often. How much "authority" ought we try to assume? And to what in the condition of the people we were visiting ought we to respond: their inability to vote, or their joblessness, or the low wages they received when they did work, or their social exclusion from various public or private facilities, or finally, and most vexing, their own notions about the truly significant as opposed to the thoroughly insignificant? When "our" purposes ("goals" they were often called) coincided with "theirs," then naturally there was nothing to worry about. When "they" voiced our sentiments, we were pleased and encouraged: on with the struggle! But often enough we heard things expressed which in the beginning we simply ignored, then later on, after months turned into years, had trouble ignoring.

Here, for instance, is a tenant farmer from the Mississippi Delta speaking. The year is 1965, but I wonder whether Doris Ulmann would find him any different from those she watched and no doubt listened to back in the 1930's: "There's a lot of trouble we have. I'm sure of that. I'd like to see a better life for my children. I look at them, right into their eyes, and I wonder why the Lord has decided it's for us to be so poor while others are born lucky: they will have plenty of money when they grow up, and people will respect them. But God has His plan, and don't ask me what it is, though we'll find out—come the day we die. Until then, you have to get up and do your best and go to sleep, so you can get up the next morning. That's how it has to be, and I'm no one to stop and figure out another kind of life. The civil-rights people, they come knocking on our door, and they say, Organize. They say, Tell the white man off. They say, Change the way you live.

I nod to them. I'm in favor of change. I ask them if they'd prayed to God before they came to this county, and I believe they don't hear me, so I repeat myself, and they smile and say no. I tell them they ought to talk with the Almighty Lord before they start out— every day they should. One of them asked me how you do it, talk with Him. I thought he was being fresh, like my little children can be, so I didn't answer him. I stopped talking. Then another one told me he was sorry they'd come and talked like that, and they just want to be of help, and maybe they'd come and visit another time. I told them any time is all right with me, so long as I'm not in the fields; any time except Sunday. We're in church then, and we don't get home until the day is almost spent and only a few hours of the sun left. So they said yes, they'd be back soon, and I said yes, that would be fine, and they never did come back. They told our minister that we were hard to get to know, out here in this county, and they thought they might keep to the cities and the towns, you know.

"When I go to church I pray for us all very hard. I pray for those civil-rights people, too. They need God's advice. He is the one who will save us all one day. There are times when I get to feeling low—so low, I can't picture myself ever being lower. I don't cry, but I feel like it. I turn to my wife and I tell her I'm in real trouble, worse than any the boss-man or the sheriff can cause. She knows what's the matter, and she tells me we'd better quick go to see the minister and he can read the Bible to us. I tell her it can wait until Sunday, and she says no, it can't, and it won't. So we go.

"Jesus Himself had His low times, you know. Especially at the end, He was in real trouble. He thought the Good Lord had gone and left His only Son, and wasn't going to help Him out. But He was brought up to heaven, and that's where I hope and pray my family will go, each and every one of them: they'll be saved—and like it says in the Book, there will be a new heaven and a new earth. This here earth, it's in need of change. One day the rich and the mighty will fall. I'd like to see that happen before I die. I'll be listening to the minister read on Sunday and I feel like standing up and telling everyone that we should leave the church, leave the tabernacle, even on Sunday, yessir, and march down the road, until we reach the county courthouse, and just like the civil-rights people say, just like Dr. King says, stand there and pray hard for those whitefolks; because they are sinners, let me tell you, and they are never, never going to get into heaven, not if you believe what Jesus Christ said.

"I don't understand how a white man can hate a colored man, and squeeze everything he can out of us, and call us all those bad names, and still expect Jesus to say welcome

when Judgment Day arrives. There are days when I don't want to wait for any Judgment Day. There are days when I'm ready to fight. Like my oldest boy says, we don't have anything to lose, anyhow. Of course, he's in the army, and when they go away from here they get big ideas: they'll be free. I'd like to see anyone fight the Mississippi State Police; I'd like to see what would happen then. People say that we should fight for our rights, and not just pray. 'Don't just pray,' my oldest son says when he writes us his letters from over in Europe, where the army sent him. I'm not able to write much back to him; I never did learn my letters too well—enough to say hello and send my love to the boy, and that's about all you really want to tell anyone, I guess, when you come right down to it. But I have my daughter, she's good with her letters, answer back: 'Daddy isn't *just* praying; he's praying as hard and as long as he can.' Then she reads it to me, and I say amen, and she goes and mails it.

"We're tested every day. The minister is tested, too. I don't worship him; he's one of us. My boy in the army, he says the ministers are all no good: they cheat, and they steal, and they lie, and they're full of themselves, and in their eyes no one else is as good as they are. I agree that there are a lot of no-good ministers. They live pretty well, too—better than I do, that's for sure. But if Jesus Christ was tricked and fooled by His own followers, why wouldn't you expect it to happen right here in Tunica County, Mississippi? I ask you! When I'm in church I'm talking with the Lord. I have long talks with Him. The minister is there to bring us together, and help us talk with Him, but the minister is like anyone else; he hasn't been judged yet, and he won't be until he crosses the river and meets the good Lord, Who is waiting for each and every one of us. When I see someone being baptized, when I go and hear the minister marry two people, when I'm at a funeral, and we cry and cry, then I feel especially close to God, and I can practically hear Him telling me to keep the faith and trust in Him, and even if we have trouble and more trouble—so much trouble!—and even if we seem closer and closer to having nothing, not even food, He'll still be eying us, and watching out for us. And if we die, it's because He's decided that they're no good, the big folks, be they white or colored, and the time has come, yessir it has, for us to go to the promised land, and meet Him and be judged.

"Judgment Day, that's the day a lot of colored people are waiting on. It would be good to have a day of reckoning right here on this earth, even before we go to the next. But I don't have much hope. I think we've got to be good and true to our Lord and Savior, and try to keep going. I'll wake up some days and I don't even want to open my eyes. I'll be on the bed, and I'll be seeing all I have to do, and my hands begin to hurt, right there in

bed, and so do my feet. Once I even began making noises, and my wife wanted to know what was ailing me, and I said nothing—yet. She said she knew how I felt, because it's in her to cry, when she wakes up, and she has to hold her hand over her mouth to stop the noise. But we get up, and we're doing all right, we sure are, once we have coffee to drink. I need coffee; I don't have much else, but I need coffee—the hotter it is, the better I feel. I'll take a piece of bread one day, but the next I won't want any. My wife wants to push the bread on me. 'You'll be working hard,' she tells me, and so I'll need the bread. I can't disagree, but I kid her. I say she's working for the bossman: she wants me full of beans, all fueled up with bread, so I can work harder on the crops. She doesn't like to hear that. She tells me I'm a mean man for speaking like that.

"I don't mean to be mean. I try to speak the way I would if the Lord Himself had come down to earth and was visiting us. My daddy used to give me long talks. He'd tell me to behave. He'd say if I didn't, the white man would come and get me. He'd say a colored man has to be a gentleman, a real gentleman. He'd say a colored man has to be a Christian, a real Christian. He'd say it doesn't make any difference if the white people are bad-spoken, cussing one another and calling us every bad name they know. That's all the more reason to show them up: because they have the devil in them is no reason for us to give in and let the devil claim us. My daddy would tell us other things, too; he was good at giving us advice to follow. He'd say that when you pass a white man in the street, stay clear of him. It's not only because they can cause trouble for you; it's because they have a bad streak, and you never can trust them, not even the best of them. And when they come up to ask you something or tell you something, the best you can do is be quiet and respectful. Say, Yes sir; say, Yes ma'am. Try to be obliging. My daddy must have told me one thousand times: try to be obliging. The colored man was put here to be obliging, I'd hear Daddy say, and I wanted to say, No, he's *made* to be obliging, whether he likes it or not. But I didn't dare go and say anything different than what Daddy said. I'd tell my mother that I wasn't sure *everything* Daddy said was right, because I know we have to oblige the white folks but that doesn't mean God *meant* for us to be like that, afraid of them. She would tell me that Daddy felt just like I did, only every single colored child has to learn his place or it'll be a lynching he'll face: they'll come and get you and choke you to death, or put a bullet in you, or they'll fix up a charge against you, and the next thing you'll know, you're behind bars, in the jail, and Lord, once you've gone there you'll never get out, except when they want you to, and don't depend on them for being full of charity. If you grow to be a sassy nigger, my mother would tell us, you're as good as dead: you'll be

killed or you'll be locked up for life and they'll work you to an early grave."

At that point he drops his head, almost as if *it* were right then and there headed for the grave. I have, of course, edited his remarks, and those of others I draw from here in this essay. I have pulled together sentences, statements, casual comments or rejoinders, from many particular conversations, and tried to put the words into the language people like me speak and use in writing for those who buy books. Unlike Doris Ulmann, a writer can't capture a moment and offer it, pure if not so simple. Words have to go on and on until somehow they reach a certain "mass," and hopefully there is a bit of an explosion: the reader and the writer—or in this last case an obscure Mississippi tenant farmer— somehow have met and come to know one another through the printed page. But that head, dropped down, resting almost on the chest, was a man's effort, I believe, to say something to me without the use of words. I record the gesture here as best I can, and I do so with special conviction: I am not so sure Doris Ulmann didn't, long ago (it really was another time, not simply a couple of generations back), come upon men and women similarly moved to lower their heads, lower their spirits, it can be said, in a painful, anguished effort to speak the unspeakable. What we take to be quiet humility can be a sorrow so private and so terrible that nothing in the way of words will do; the sorrow is in fact the person's ongoing life—for a moment given brief expression by the body, whose language has its own integrity.

I also remember an extraordinarily sensitive and decent minister trying to tell me what some of those dropped heads mean to him. Like me, he had long since stopped trying to guess what the people themselves had in mind as they slowly or precipitously dropped their gaze, then their head, and, often, slumped just a little: "I've been preaching twenty-five years, and I may have to go another twenty-five until I'm called. Then they'll decide up there what to do with me. I try to be the best preacher I know how. I try to speak God's words, as He did in the Holy Book. I fail; often I do, I know. I'll be too selfish; I'll be interested in how *I* look, and what *I* say. You can't trick the people sitting there before you—oh, for a while you can, but not for too long. They know what's happening. Evil crosses the air, no matter how we try to hide it. I can use all the nice words I can think of, but if I'm preening myself, like a peacock, the people will soon know. Then *I* find out. They start whispering; since I have been paying such attention to myself, they do the same. A few want desperately to talk to God, though. If I won't let them, if I put myself in their way, they grow sad, and finally they leave. I don't mean they leave the church— no sir, they stay. They just turn their minds to God. I'll see them: they stretch their necks

up and they're praying, even while I talk, or they have their heads way down, and it doesn't make any difference what I say, because they're sending their own message to the Lord. With some, you'll see their lips moving silently; with others, there's a far-off look on their face.

"I'll put aside my own sermon when I've been smart enough to see what is happening. I confess to my brothers and sisters that the devil has taken me, caught me in his grips. It is hard to fight pride; we forget that we are servants of God, and we want to be masters of men. I do believe that Jesus Christ spoke words that every colored man hereabouts knows: If you are low down in the world, and if you are put upon and scorned and rebuked, and if you have learned to be resigned, every day resigned to God's Will, no matter how unjust it seems, no matter how hard the road He has set out for you to walk— well, then you have learned to forget yourself, and be part of *His* world, and then you are living His kind of life. You are walking as He did—among the weak and the sick, the beggars and the outcast, the lame, the halt and the blind. And remember, Jesus Christ was not rich, and He was not respected, and He was arrested and given the death sentence, and they had Him locked up, and they called Him all the bad names they knew, and He was betrayed, and when He was alive He was treated bad, real bad—so you couldn't probably tell, if you'd been alive then, the difference between our Savior and all the people He wanted to heal, and He wanted to talk with, and He wanted to feed, and He loved so much.

"There will be a day when I look at one of the people in my church, praying so hard, especially one of the old people, and I think to myself: Jesus Christ, our Lord and Savior, why, He might be here, right here—in the form of that old gentleman there, or that lady. I hope I don't sound like I'm being blasphemous. But ever since I was ordained, I've believed that Jesus visits us here on this earth. I wouldn't want to preach a sermon on the subject, mind you. I wouldn't want to go back and argue with my seminary school teachers about the subject, mind you. I wouldn't want to be quoted by some reporter, who would put it in the newspaper, and the next thing they'd be running me out of town. But I can't help but think that when I'm baptizing, or when I'm talking from the pulpit, and there's a look in a child's eye or an old person's eye that holds me and goes right through me—it can silence me, and I'll feel like getting down on my knees and praying and praying—well, when that look comes, it's the Lord, that's how I feel, it's Him. He's not here to visit *me;* He's here because He has His flock, and He tends to it.

"There's an old woman I know, who came up to me one day, and she asked me if I'd

felt funny that morning as I talked, and I said yes but I didn't tell her any more. She said she was sure I had gone through a dizzy spell or something, because she saw me pause, and I wiped my brow and took a glass of water, and it was hot that day, very hot, and I must have looked up at the ceiling, with the fan going around, and I looked as if I needed to use one myself. But she told me, 'Mr. Reverend, I looked at my sister, in front of me with her son and her grandchildren, and she was looking at the New Jerusalem you were mentioning; I know she was. I've never seen such a look on her face. She must have been seeing the Lord, and maybe He was smiling at her. She had peace on her face, a peace we're never going to have, any more than a few seconds or two, until we go to Him.'

"That's what she said, the old woman, and I don't have to add that she practically threw herself on her knees, to apologize for saying what she did, because who was *she* to have the idea that she'd seen her sister looking at the New Jerusalem and being smiled upon by the good Father of us all. But I took her aside and I told her the truth; I had to. I told her that I'd suddenly seen her sister myself, as I was talking, and that was why I seemed to stop for a moment in the middle of my sermon. I don't think she liked hearing me say that. It's all right for a plain, ordinary old woman to think a miracle or two happens, even among us colored people in the state of Mississippi. But for the minister to agree, and say he saw the same miracle—it's frightening. She left right away; she said she had to be home, to help with the cooking. But she was back the next day, and now she was quite nervous. Could it be that Armageddon was coming, she wanted to know. She said it was a sign, when both of us felt the same about her sister.

"I told her no; I told her that since I'd been a minister I'd been seeing the Lord in a lot of people, herself included. That made her even more nervous, but I quieted her down. Three months later her sister died, and to this day she believes that God was getting ready to call her sister that Sunday in church. But that's not my way of thinking; I'm inclined to favor my father's view. He was a preacher for forty years, and he would tell us that sometimes he'd see a face or two shining before him while he struggled to say the right words, or read a passage from the Bible, and he was convinced that it was the Almighty Himself, passing in our midst for a brief second or two, and telling us that it is an awful time we have, He knows, but even as He could go through His trials, we can go through ours. And I will say every week to my people: We cannot fool ourselves; we cannot think we are going to have it much easier; we have been put here to suffer, and to suffer more than most people do, and the only consolation we can have is that most people don't get crucified, but Jesus was. So, He has chosen us to suffer, and that's why we

have to work harder than most people at being faithful to the Lord and obedient to His wishes. That's why we have to be good people right here, no matter the pain we have to bear. We've been chosen. And the people will listen, and they will say, Yes sir, and they will say, That's right, and they will nod, and they will tell me to say it again, because it's the truth. And often I do; I repeat myself."

He is not unaware of the irony he has implicitly stated: that the poor must be rich in certain psychological characteristics, and they are the most demanding ones—patience, charity, consideration for others, thoughtfulness, humility, not to mention the most extraordinary, because the most tested, sort of religious faith. One runs substantial risk making generalizations about any group of people, and certainly a good number of rural blacks, or rural whites, of the South do not at all live up to that minister's injunction, even as they would not quite appear forty years ago as Doris Ulmann's subjects do, and even as they would today come across to an observer as crude, violent, mean-spirited, narrow and ignorant people. One uses that litany of adjectives without prejudice, but rather, descriptively. One simply wishes to stress that the "nasty, brutish and short" life Hobbes referred to has by no means disappeared, for all the wealth and power this nation boasts. I have in mind black men from Mississippi who drink what liquor they can get, when they can get it. I have in mind black men from agricultural counties of the Southern states, or from small towns or cities in those states, whose appearance or behavior would satisfy any number of their critics, if not those who hate them outright— and sight unseen. People treated with contempt can become full of self-hatred, especially if generations of such a psychological cycle have been allowed to exist. People denied their various rights, not only political but human rights, can feel themselves subhuman, and soon enough act that way. People treated gratuitously and brusquely as children can become childish, not childlike. People shown scorn can scorn the requirements any of us ought to have: caring for ourselves, treating ourselves with a certain respect, so that we will, presumably, be able to offer ourselves intact and whole to others—those we love, those we work with or for, those we meet in the course of our daily lives.

I have to say all this because it is possible that some will look at Miss Ulmann's photographs and not so much romanticize the black people she presents as fail to understand the high cost necessary for the nearly spiritual beauty she was able to see and document. There was no doubt much she chose *not* to photograph—or, having photographed, set aside. Certainly I have to sift through carefully what I hear, so that I can find those important and revealing and suggestive moments which, one hopes, make a difference to

the reader. Not that one wants to distort the truth of things, build up a case, or by in-direction tear down someone else's case; the issue is one of balance and, I suppose, dra-matic truth, which means that the issue for Doris Ulmann had to be broadly artistic—she was a photographer who wanted not to pretty up what she saw, but to encompass its various sides. Her work is in several senses *reflective:* she meditates on people to whom she is drawn; she is reached by those people, has touched them, and so can come forward with much of them, which, it can be said, has become hers to know and present to others; and she quite literally has caught those light rays as they land on people and bounce back upon a sensitive eye—in turn connected to a mind able to appreciate the revela-tory possibilities of anything, however incidental or accidental or tied to nature's rhythms. She is alert to the sun and its power over people, or shade and the refuge it offers, or animals and the tenderness or seriousness of concern they elicit, or clothes and the quite hypnotic effect they can exert. She dwells on people who are seemingly living the least interesting and notable of lives: certainly we know them to be hard-pressed, impoverished, largely unselfconscious, and glad if there is food and work tomorrow—never mind the day after tomorrow. If in her hands they become a touch ethereal, or ghostlike; if they seem almost too delicate, rather like spirits; if their gentle, courteous side seems a bit much, and maybe hard to believe; if they strike us as incredibly highbred and wellborn—then we have been forced to stop and think about a number of paradoxes, not the least among them our assumptions about the difference between others and ourselves, their lives and ours.

I recall a confrontation I was once put through in Alabama, about fifty miles north of Mobile, by a woman who certainly is no Doris Ulmann—I doubt she has ever seen a camera, let alone the Upper East Side of New York City—but who in her effort to come to terms with her own life's various sides, and in her natural, simple responsiveness to the world around her, does indeed, I would think, possess Miss Ulmann's kind of sensibility. In the course of one series of conversations with me, she had this to say: "I will walk toward the fields, and I'll be carrying something, and I know I have to get to where I'm going, but I stop and sit down for a few minutes. Lord, I don't believe I'm lazy. I'm the other way; I can't sleep, if I know I have something important to do the next day. But my feet will tell me it's time to stop, or it might be my head that tells me: Easy for a second, Ruth, there's plenty of time—and even if not, there has to be a moment when you stop and look around. I was always doing that when I was little; my momma would say that Ruthie does her chores, but she likes to have time to think about what she's doing and what she's

going to be doing. Truth is, a lot of the time I wasn't doing much thinking; I was just sitting, taking in the world. You know what I mean? I'm not sure I do myself!

"Well, I guess I know what I was doing back then, when I was a girl. I was doing what my grandma always told us to do: Think of God, once a day at least, and enjoy the sight of His world, even if for a second—that was her advice to us. She'd tell us that no white man can take God from us, and no white man can stop us from looking at all that God has given us, no matter the trouble He's testing us with. She'd walk with us, and she'd grab my hand, or my sister Estelle's hand, and she'd say, 'Just catch sight of that!' I wouldn't even know what she was looking at. I'd be surprised, I guess, until she'd point out a wild flower, or some animal—a frog or turtle, don't you know—and then I'd say yes and glance over and a second later go on with my own thoughts, I guess. But she was a tough, old one; she'd ask me, 'What you thinking in that head of yours, Ruth?' I'd tell her, 'Nothing.' And I was telling the truth, because how do you ever know what you're thinking: there'll be one thought, and then another, and the thoughts come and go so fast that you don't know what to say about them. My grandma knew we were just going along—not really doing anything, not really thinking about anything important—because she'd say, 'I know you girls have no big ideas bothering you; that's why I want you to pay more attention to all there is to see about you. If you had a good reason *not* to, then it would be different.'

"That how, because of her, I'd end up staring at a caterpillar, or trying to keep after a butterfly with my eyes. That how, because of her, I'd get to talking with the birds. They'd keep their distance from me, but they were always ready to come back to where they were if I'd just oblige them and move away myself. I guess I'd tease them. I hate to admit it, but I'd walk just far enough away so that they would move from where they were to where I was. Then I'd start coming back toward the spot, and they'd pause for just a second extra—I swear, it was as though they were saying to themselves: That loony girl, she's already left here, so she won't, she just *won't* return so fast. Well, I *was* loony, and the poor birds, they'd have to fly away once again. After a while I'd get tired of what I was doing, and I'd move along to something else to keep me busy. The birds, they never got tired. Birds have such patience! My grandma had such patience, too! And I'll tell you, she would give us her sermons; she'd tell us that she learned her patience from watching a turtle move across the ground, or the birds, or she liked the squirrels because they never seemed to mind all the climbing and jumping and running they have to do, just to get some food. 'They don't get anything easy,' she'd tell us. 'They have to keep on

the move all the time, just to get by,' she'd tell us. I don't think I'd be able to know the field out here the way I do, if it hadn't been for my grandma.

"The day she died, you know what? The day she died she made my daddy and his brothers lift her out of the bed, with her bad pneumonia and all; she wanted to take another look at the field, because it had rained. The sun had just come out, and she was sure there'd be a lot for her to see. Don't ask me what she wanted to see! If I had pneumonia, I'd be glad to be resting on my bed. My daddy says she pointed out some good places where they could get worms—the bait they collected and sold, or used themselves—and then he took her back inside, and soon she'd left us. Daddy said she lay there and there'd be a gust of wind, and she'd think it was the Lord coming; when she was still there, with the wind gone and it as quiet as can be outside, she'd say that maybe the next wind would be the one: out from the pine trees across the field and into the cabin, and then out again—with her! Oh, she was soon right; late that afternoon she passed. My daddy said there *was* a wind, a strong one that came and lifted up some papers on the table, and she took a big, last breath, and that was all. She was with God.

"I've been getting older myself. It used to be, I'd think of death as far, far away. It used to be I thought that old people die, and the very young live forever—just go on and on. But no one does. And when you have your own children and lose some and you feel yourself tired more and more and there'll be a white hair, or more wrinkles, then you know the time is coming nearer and nearer. That's what I think about most when I cross the field. I'll stop and rest on my favorite rock. I sit on it; the Lord must have meant it to be used by us, because it's got a nice smooth surface, and you just slip onto it, like a chair, and your legs are comfortable—not dangling and not too bent up, if you know what I mean, but just the right height. I look at the sun—a quick look, of course, except if it's late in the day when you can catch an extra second without hurting your eyes. I wonder sometimes if the sun doesn't get tired, or the moon: every day, no matter what, they're up there. My boy asked me last week what would happen if the sun stopped showing up. I said that would mean God had decided to bring every one of us up to Him for Judgment. He'd sure have a lot of decisions to make, all of a sudden, if that's what He'd do. But He won't, I don't believe. He wants us to live and die, and others to come after us, just like others have come before us. He doesn't want to wave His hand and stop the whole world. He has the whole world in His hand, like it says in the song, but He'll let some sift through His fingers, and some stand in the palm of His hand—you see what I mean? Then He'll get another handful. It's like what I do sometimes: I pick up

some of the dry earth there, and I let it go slowly, and I'll do that a few times before I'm ready to get myself up and start walking again.

"There will be times I want to go think. My husband is upset. He's on the bottle again. He comes home looking very, very bad. There's a far-off look in his eye. I'm afraid he'll go and hit me. He's done that a few times. He usually warns me, though: he says, Better clear out, and take the children to my aunt, because I'm not fit to live with tonight. I don't argue with him; I have learned to respect his every word. If he says he's not fit to live with, then he's not fit to live with. I do as he says. I take the children away. I even take the dogs away. To tell you the truth, the dogs don't have to be taken away; they're the first to know. They come and tell me, as he comes near, that there's trouble ahead. They yip, and that's their way of saying that after they've done their duty and warned me, they're leaving. It doesn't take but a few minutes and we've all scattered. I'll leave the kids off and walk back. I'll stand near the big tree—it's our house's umbrella, you know—and listen. If we've gone he's likely to be quiet. And with luck he'll just lie on the bed and fall off, and sleep through to the morning. It's when we're around that he's likely to be noisy and cause us all trouble. He might keep drinking, though, even if we're gone. Then he's liable to hurt himself; he has, a number of times. That's why I sit out here, behind the tree, so he won't see me even if he should look out the window—and he won't, most likely. If I hear him fall and start shouting and swearing, then I can come in and be of help. When he's been down on the floor, you see, he's as good as a baby, no matter the amount of wine in him.

"That's when I do my talking with the Lord—more than any other time, even in church. In church you sing and say your prayers and listen as hard as you can to what the preacher says and speak up when you feel the message getting to you. In church you don't have a good, quiet talk with the Creator. There are all the other people nearby. But out there, under our tree, and with my husband stumbling around, I talk to Him and I feel alone with Him. I call on Him: I ask Him my questions, I tell Him my troubles. If my heart is aching, I let Him know; if there's something especially bad bearing down on my soul, on my conscience, I speak up. Then I lean back, and I might rub my back up against the tree, and I might look at the clouds, or if it's dark, the stars, and pretty soon it comes to me what He thinks is right and what I ought to do. Of course, there will be times that my husband will have a change of heart: even though he's pretty well under the influence, he might call me in a nice voice. Then I'll come in, and he takes me around. He might start crying, you know. I just hold on to him. I try to soothe him. Your husband is

your baby, too. It's too bad it takes the liquor to get men feeling a little softer, more like a child or a woman. Men try to be so hard. They won't cry until they're hurt real bad; then they become like very small boys who cry when they're hurt, then stop. I have to hold him and hold him. I have to sit him down and try to get some food in him; that's the hardest — and you know, it can all come up, right up on him and me both. I have to steer him over to the bed. I have to loosen his clothes and take them off if I can, and cover him; even a baby will reach for the blanket and pull it over himself — but that alcohol, it's the devil's instrument, like the preacher says, and it ruins people so they don't know as much as an infant.

"Even then, when it's safe to be inside, I'll go out again for a while. I like to listen to the day setting and the night starting up. There are the animals, talking to each other, and the insects, now that us people have quieted down and gone inside. There is the night breeze. There is the wise old moon, coming up to take a peek at us; the moon is smart, because she gets away and hides in the daytime. Like my mother told me, there's a lot of misery that the moon never rests her eyes on. Lucky moon! The dogs will be resting, and if it's hot I listen to them taking in the air, and it reminds me of a clock in the bossman's house: back and forth, up and down, the breathing will go. We have our pony, of course, and she comes up to me. She nuzzles me, then she moves back to her grass, and I listen to her working on the grass. It's a low sound, her teeth cutting away, on and on. After a while I get tired and I go over to my aunt's or I tiptoe into the house. If he'll be asleep, I can more or less go about my business. He's dead to the world; he's off recovering. Maybe the Lord pays special attention to people who drink — gives them a lecture while they are asleep. But some don't listen to His lectures, if He does give them. My husband minds Him; he'll stay away from the bottle for a good long time after he's fallen into the hands of temptation. I promise my children the next day: Rest assured that for days and days, weeks and weeks, your daddy will be fine. But I can't say years, no sir, I can't.

"I don't much keep time, anyway. I have all I can do to keep up with today. I don't think of yesterday much, and tomorrow is too far off. I'll tell you what: with me it's either this here minute, right before me, or it's the next world I'm going to; it's the one or the other that I think of. I don't have to go out in the field or under our tree to think of the Lord. My grandma told me to call on Him whenever seems a good time, and I guess I do. I'll be walking, or I'll be messing around in the back, or straightening up after my kids, or preparing to go in and cook — and all of a sudden I'm of a mind to ask Him a

question. How am I doing, Lord? Should I try harder—with my husband, so he'll never again touch a wine bottle? I don't get answers. I get a feeling. I don't know how to tell you. It's a feeling, that's what it is. The answer is the feeling. That's the nearest I can come to it. I wish I could get nearer.

"I have friends, I have a sister—well, they'll tell you the Lord speaks to them, and they mean it. I hear them reciting the words they've heard. They'll go bragging to the preacher: He told me this, and I heard Him say that. The preacher, he's a sly one. He doesn't say yes and he doesn't say no. I went to him once and asked him why it is *I* never hear God's voice, not direct, like it'd be on the telephone, I suppose. 'Oh, Ruth,' he told me, 'that's because you're an honest woman.' So I thought about that. Then I went back to him. I said, 'Mr. Preacher, were you telling me that my own sister and my best friend and my other friend—I grew up with them—are not honest?' And he said I was getting everything exaggerated; that's the word he used. He said God's ways are mysterious, and I should not try to understand how He goes about doing His work. I agreed, and I told him I was sorry to come and bother him. Then, as I was leaving, he called me back and asked me if I believed they were hearing God's words, or if they were hearing their own words and calling them God's. I said, 'Mr. Preacher, how can I answer that?' I told him that was what I wanted to know from *him;* that was why I'd come to see him. He said he was sorry, he'd forgotten. He said it's best for everyone to walk his own road and hoe his own path. I'd heard him say that a thousand times before, the last time just a few minutes earlier. So I begged his forgiveness, because I had to leave in a real hurry. On the way home I thought to myself that the preacher is a fine man, and he's a man of God; but there's no one who's God except God Himself, and if you don't know that, then you're in the worst trouble possible, but if you do know that, then you must be at least a quarter of the way along toward His favoring you. That's how I see it."

She can stop at such a point and quite literally and emphatically make it her business to do just that: see. I mean, she will look up—not way up, just a little further up than she (than one) normally does in the course of a conversation. She is not gazing too much; she is not off somewhere, distracted or dissociated or summoned by some private vision or voice to which no one else is privy. She is simply being carried along by both the substance and momentum of her own ideas, speculations, interests, questions and concerns, as they one after the other emerge. Looking at some of Miss Ulmann's portraits, black women in white, a proud black man who has a somewhat lofty or quizzical look to him (he resembles, to a degree, William Faulkner), I thought of the particular men and wom-

en I have known these past years—and their ways of describing one another: "She's a hard one to figure out when she gets to brooding"; or "I never can know what gets into her head when she decides to go off and be by herself until she's good and ready to come and speak, and then her face tells me to prick up my ears, because I'm going to hear a mouthful"; or "I'll look at him and I see a white man—he's white like we all are, some part white, but he's got more mileage out of his part, and I do believe he makes the white people nervous because he's got some white man locked inside of him who keeps trying to break out, and the white man tries a little too hard and that's why he looks as he does."

Who can put into words something as ineffable as a look, or the strange effect a tree can have—or a cemetery, or a small pond—on the minds of various individuals. "I go to the cemetery to find peace; to be near God, because I'm sure He walks through there every once in a while." The elderly lady who says this is hard put to say why she finds the cemetery even more significant to her, religiously speaking, than church, but the fact is that she does. Maybe she is simply a person with roots, deep roots indeed. These roots are commemorated at the cemetery, and even though she has nothing else, she feels she has a lot because she can, at her discretion and will, go seek out and contemplate them: "I'll be questioning life; I mean, I'll be in danger of losing my faith. I'll be wanting to find a shotgun and go kill every white man in the county for all they've done to my people. Even Dr. King's words don't reach me. I fold my hands and tell myself to hush up, and be a good girl, and besides the whites have the police and the army and God knows what—I wouldn't be surprised they could pull out airplanes and bombs if they needed them. Anyway, I'm afraid I'll do something that will get me into bad trouble, and that's why I try the only thing I know to prevent it: yessir, I go visit my dead people, and I talk with them, and they quiet me down. Oh, do they!

"They lived through worse, you know. As bad as it is, it was worse; that's what every colored man and every colored woman has to teach their children. I tell my children it doesn't matter—call yourselves colored or Negro or black; it doesn't matter—so long as you never forget the people who have gone before you. Listen to the dead people just like you listen to people who have their big voices. Listen to the dead ones. They speak, too; oh yes, they most certainly do! I hear them talking, louder than anyone alive. I used to be taken to my grandmother's grave by my mother; she'd sit down, cross her legs, and smile. I'd ask her why we were there. She'd tell me we were visiting, just like we do when we go see our aunts and uncles. There was a time I'd be scared, but my mother

made me see that it wasn't scary, it was a real quieting time: we could think about Grandma, and she'd come to us. Don't ask me when I first realized Grandma was visiting me as well as my mother, but I did, and to this day I go visit her and she comes to me — and there will be times when He comes, too, the good Lord. I know when that is, because I might begin to shake a little. I might shudder: will He take me away? But He never has, and besides I've learned to trust Him. There are just so many people in the universe who will trick you: millions of white folks — but not Jesus!

"When I leave, I'm feeling better. I'm feeling like I could be in air, not walking on the path over there. I'll be able to smile to myself, and I'll be able to say to myself: You see, nearby are your very own people, blood of your blood, and they lasted; through all the bad, all the evil in the world, they lasted. That's why you can last, too. If you carry the curse of being colored in your family, then you carry the history of being able to overcome — like Dr. King says, and the other civil-rights people: We shall overcome. I'm all for the civil-rights people; a lot of us here are afraid of them or don't trust them, but I do. The only thing I don't like is when they tell us how bad it's been, and how awful it is — the way we live. It's been bad; and it's been awful, all right. I have to admit that. I just have to add my belief: my grandma and my mother, they were good people, for all the suffering, and they could smile plenty. It wasn't all tears. We shouldn't tell our children that it was all tears and it is all tears and it'll never be anything but tears until we vote and go to the white man's movies and restaurants. I look at those white people, and *they* make me want to cry: they're enough to bring a lot of tears, and I'll tell you why — it's because they're the most unhappy people in the world. And I'll tell you why *that* is: because they know what's coming. Yessir, they read the Bible, too. Jesus Christ has told them what He thinks of them. They run this world, but they aren't going to run the next one. And even with all their money, they're not as happy as they seem. They come by, and tell us how bad the weather is and how bad business is, and how bad their children are behaving.

"My son came in from school one day; he's in the sixth grade. The bossman was standing outside, talking to my husband. Then he came in and he asked me how I do it. I didn't know what he meant. He said, 'How do you bring up your children to have such good manners?' I didn't know what to say. Finally I said, 'Oh, I spank them good when they need it.' He said I was smart, and I guess he was telling me his wife isn't so smart, because she won't lift a hand upon their boy, and he's my boy's age and he's always getting into trouble. My husband sees him, and he says he's just a mean little one — a real

bad mean little one. My husband says he thinks the boy has the idea that he's the most important person who ever has been born, and he goes around being nasty to people, including his own mother and his daddy, and they just sit back and take it, and they don't lift a finger to put that child in his place, and that sure is bad for a child, I think. That's why I said it's no good, owning the whole world but not knowing the fear of God. Like the Bible says, you're going to suffer if it's that way you live.

"My sister has spent her whole life waiting on them, the white. She comes and tells me the stories; it's enough to make you pity them—and that has to be a lot, to make *me* feel sorry for *them.* Their children talk back to them, starting when they're just little ones. They put on airs and pretend when they have company; then after the people have gone they fight cats and dogs. My sister says they call each other worse names than they do the colored people. The man, he has his television, and he goes into a room and he doesn't close it, mind you, he locks it. He says the children bother him, and so does his wife. The wife, she has her own television. She asks my *sister* to go see if he wants any-thing, or to tell him about a program she thinks he might like. When his parents come, or hers, then you can bet every dollar you'll ever make that as soon as those old folks leave, there will be hell to pay. Lord, do they fight. They swear and curse at the old folks, and then they're going after each other, and then they say the worse words you can imag-ine at their own children, and then they stop, and my sister, she's glad to be slipping out of the house. She'll come and tell me all she's heard, and she'll be sure that as soon as she's gone they'll start in with the niggers. Well, I tell my sister to be glad the niggers are last on their list: by the time they take to cussing us out, they're tired and ready to go to sleep.

"The worst is when the man, the bossman, sits in his chair, and he can turn it every direction you can imagine, and he has his whiskey with him, and he has a control that can switch the television station from all the way across the room—don't ask me how those things work—and he has a buzzer or something, so that if he wants my sister he can press it, and she's there, fast as can be, asking him if she can give any help. And he's the one who's always calling *us* lazy and no good and all like that. I'm heavy myself—too much starches, I know, but they're the cheapest to buy. He's twice as heavy as any Negro I've ever seen, and he can eat the best food in the world and not worry about the cost. My sister says it hurts her more than anything else, seeing all the good food they buy, and he picks at it, and then sits there at the television with his beer or his whiskey and his potato chips and his pretzels. And when he's driving, he has a box of candy bars in

that car, and his wife is not supposed to know, but she found out and there was hell to pay. So, like I said, they have too much for their own good; that's how I see it.

"I wouldn't mind having the money they have. I can't be honest and say I'd turn it down. But I'd go right over to the minister, if I got my hands on even the tiniest share of their money, and I'd give half to the church. Then I'd pray to God, that He give me strength and wisdom not to let that money go to my head, and get me drunk as can be. My daughter, she's a smart one; she says, 'Momma, with all that money you'd become just like the white people—you'd get sassy like them and you'd think you're God Almighty like they do, and there wouldn't be any difference at all.' I tell her I'd like to get a chance to prove myself, that's all. But later I'll be thinking, and I'll decide that she's right, that smart daughter of mine. And maybe that's why the good Lord has kept the Negro people living as we do: we're not tempted; we're not tempted to be the rich ones He talked about, who'd never get to Heaven. It's pride, like the minister says; it's pride that curses white people. They've stepped over everyone and taken from everyone, and now they've got everything—except that there's the minister, drinking and swearing, and his son, as fresh and mean as they come, and his daughter, running around slapping other people's children and pulling her tantrums, and his wife trying to be nice to everyone, then cussing or crying later on. Then *she* does her drinking, too, when she gets home. So the Lord is giving white people fair warning: they can't have it both ways. If they're going to win here, they're going to lose the next time, up in heaven. It's not that they're rich that will turn the angels against them up there; it's that they don't know how to be good people. And there's poor people, Negro people, who are no better—you mustn't forget that. Like I once heard a preacher say in Clarksdale, when I went to visit my brother: he said it's bad for us here in Mississippi, and we're on the bottom of the ladder—but you mustn't think the Lord Jesus is going to let you all into His City He's built up there, just because you're poor or because you're Negro.

"There's no way to be saved except for each man and each woman to pray to God, and never stop praying, and then the Lord will make His decision, and it has to be person by person that He'll do it: not the rich and not the poor, nor the Negro nor the white, but me or my sister or the bossman or his wife, and it's up to each of us, don't you see. That was about what I heard the minister say, and that was a very good sermon; it got me thinking. I just sat there and sat there, and they almost had to wake me up when it was time to go. My mind had become lost in itself, I guess. But I was soon home, and I had no time for thinking, with all that I have to do. One thing, though: I told all my children

that we have to be quiet and respectful to each other, and have good manners, and not be hurting other people, and keep our tongues clean — because God judges each one of us separately, and it's just not so that if you show up in church, or your mother has prayed for you a lot, that you're automatically going to be saved. My boy asked about being baptized, and the minister praying for you — does it help? I said I was sure it helps; but only so much, because if salvation is going to mean anything, it will be because you've earned it on your own. And I think my boy understands. I do believe he understands."

I have no way, beyond what such a woman says, to account for the good behavior — the genuine courtliness, I would call it — of some Southern black children and parents I have met. There is a grace to their movements, a quietness and thoughtfulness to their way of getting along with others. For a long while I attributed a good deal of all that to the racial situation in the region: people desperately afraid and rather constantly presented with the possibility if not probability of severe punishment for the slightest lapse, the slightest breach in the segregationist "code," will naturally learn to be guarded, reticent, obliging. Out of fear they become "good." But underneath — I have often reminded myself — they seethe with resentment and rage, and in various ways, at various moments, that side of their psychological life must almost surely demonstrate itself. Nor do I wish now to disown completely such a point of view — an "interpretation," I suppose it is. There is no doubt that many blacks in Mississippi do indeed cooperate with their oppressors, say yes, go running at the beck and call of just about anyone with white skin, but all the while, underneath, and not so far below the surface, feel an assortment of unexpressed emotions: shame and sorrow as well as bitterness — and maybe a lust for vengeance as well as freedom.

On the other hand, black friends I worked with in the civil-rights movement, themselves of rural, Southern origin, have insisted that the courtesy, the gentlemanly or ladylike behavior I have seen, is not meant only for white "masters." Servile obsequiousness certainly persists on those plantations which themselves persist, however "urban" the South is becoming. Blacks in the region still pay court to whites while all the time wishing, at the very least, that they could tell them off without fear of the most severe kind of retribution. But I am told by black friends of mine in states like Louisiana or Georgia that with one another much of the graciousness, the decorum that I often have thought to be an expression of fearfulness in response to my (white, middle-class, professional) presence, is in fact very much part of the lives of such people. One young activist put the

matter quite strongly and bluntly to me: "The church has always meant a lot to my family, and to our neighbors. We come from a small town in South Carolina, and the whole town went to church on Sunday, every single person, and stayed there practically all day long. We usually went during the week, too—there was always some special reason. I read in a sociology book about the explosions of drinking and violence in some Southern towns on Saturday night; it's supposed to be 'displacement': from the whites to ourselves. Maybe it's different in the large towns and the cities; maybe when you leave the land and go live in a crowded neighborhood, all packed in and no space nearby, and when you've lost the chance to do what you know how to do—even if it's pick cotton or harvest other crops—and you're sitting there, idle and with too many strangers around, maybe then you go berserk. But I have cousins from little towns in the eastern part of South Carolina, and they aren't any different from me or my brothers and sisters. They're not 'displacing' anything. They're at peace with themselves and humble before their God.

"Has any sociologist gone into parts of upper-middle-class suburbia and listened in to the way *they* behave there, and figured out why *they're* always drinking and getting divorces and driving at ninety miles an hour, and all the rest? Who are *they* afraid of—I mean, who intimidates them so that they 'displace' their anger on themselves? You know what I think? I think you're barking up the wrong tree, man! I think there are a lot of frustrated and unstable black people, for understandable reasons, just like there are a lot of frustrated and unstable white people. When black people go North, they don't only become bitter because they've been released from the South. Why can't you say that they become *Northerners* when they go North—begin to live like they do in New York or Chicago, rather than the little towns or villages of the South? Maybe farm people aren't prepared for city madness, with its violence and meanness; so it's harder on them than it is on people who left cities in Europe for cities in this country.

"I'm no sociologist or psychiatrist. All I know is that I spent twenty years in a little South Carolina community of black people, and we were polite to one another—not just to white people. As a matter of fact, we were *less* polite to the whites. It all depends on how you define the word. We'd go along with them, and we'd even bow to them. We had no choice. But we held back, and were quiet, and never really gave them the kind of affection we felt for each other—and I'm thinking of my mother, who took care of white kids. She loved them in her own way, but she spent more time distracting them and dis-

ciplining them, and she would come home angry because she'd have to be away from us; we needed the money. She'd be more polite with us than with the white kids. She didn't come home and let out all her 'frustrations' on us. Oh, maybe sometimes she did. She was human. But think of all the white guys who come home ready to murder someone because they've been insulted and pushed around all day at the office. Why do all these white social scientists write about us as if we're so strange or peculiar—and forget about themselves?"

He went on and on. I was able to go no further with psychological "explanations" than he; in fact, I was grateful to him for taking me further than I had been able to go myself. After one has spent years with certain families it is not too hard to recognize genuine refinement and considerateness for what they are: *that*, and no "reaction-formation," or evidence of "denial" or "suppressed rage" or of feigned humility—a black contribution to the Uriah Heep tradition. It is rather obvious that Doris Ulmann observed among the people she visited an almost philosophical quality of detachment and resignation, along with a real dignity of being and poise of manner. She worked hard to record what must have struck her as both remarkable and ironic. And she succeeded. Yet, for all the achievement, many of us are not going to be completely convinced, or, if we are for a moment, soon enough we will have our moments of doubt. Nor do I think *any* "evidence," photographic or tape-recorded or both (audio-visual, as it is put today), will quite put our questions or worries or mental reservations to rest. And with good reason: it *is* bewildering to find among an extremely hard-pressed and "lowly" population a certain aristocratic quality of mind and heart and yes, bearing. Or is it that we are bewildered because our own words and concepts, rather than someone else's "behavior," cause us to be so? That is to say, are we bewildered because our various interpretations of what constitutes the "aristocratic," the noble, the truly genteel, are themselves inadequate, perhaps even unworthy?

I have been drawing all through this essay on black people whom I judge to be not unlike, in many respects, for all the years elapsed, those Doris Ulmann met and photographed. I had best at this point ask a white Southerner to speak—an "aristocrat" by every social and cultural definition of the word: "I guess I've had a very good life. I was blessed at birth; my parents were not only rich, and of 'good stock,' but they were *really* of good stock—I mean by that, they were decent and kind people, not only people whose 'background' and 'connections' were considered the 'best' by others. It's a hard thing to talk about, but I really do believe that if my parents were good and loving to my brother

and sister and me, it was because they were brought up by Negroes who taught them to be like that. There's no other explanation I can think of—not if I believe what I've read of modern psychiatry. Of course, I'm only a lawyer, but isn't it true that we mainly learn how to behave toward others in childhood from those who bring us up? I know who brought me up: not just a black nanny, but a black maid and a black butler we had, and a wonderful black gardener. The gardener taught me how to play baseball. He taught me not to be a sore loser. I guess white people don't know how to lose; all we want to do is win, always win.

"I don't want to turn into a reverse racist. I'm happy with my own children, and with their friends—all rich and white! I just want to be fair, and point out that you shouldn't classify people according to their income, or where they went to college, or even their race or religion. Or if you do, then you should understand that there's no necessary correlation between money and good manners—between social class, I guess the sociologist would say, and the social graces. I mean by the 'social graces' something more than having memorized the Emily Post book on 'etiquette.' I mean a capacity to feel real respect for other people—*as people*; that is, no matter who they are by occupation or name, and all that. I've not read a lot of psychiatry, but don't you think it takes self-respect for a person to be able to respect others? If you ask me, a lot of Negro people have self-respect. I know that sounds crazy; I know they've been pushed all over the place, and the result, in many cases, is fairly obvious: they're slow in learning, and they don't know how to take responsibility for themselves, and they act helpless or become virtually indigent. It's hard to figure all this out. Many are as I've just described, but many are the most polite and sensitive people I've ever met in my life. Talking about being God-fearing: they really *are* Christians, the ones I knew as a child, and know today.

"The only way I can put it is that there are good and bad in every group, but when you find good people among those who have been most cheated and robbed, then you've *really* found good people; then you've met the *best* people. That's why to me, and to my wife as well, good Negro people are the best people. They've had every chance to turn sour and they've resisted each time. How many of us can say we've been tested, really tested? I can't say I've been. I've had a very comfortable life. No one has got in my way. No one has taken anything away from me. Usually people give me the benefit of every doubt—more than that, they go out of their way to lend me a hand if I ask for one. People defer to me; I have to be honest and admit it. I'm talking about white people, never mind Negroes. Even when I went up North to school, I was never treated rudely. A

few Yankees had some crazy ideas—*prejudiced* ideas, *ignorant* ideas—about the South, but they never looked upon me as anything but a friend. Certainly they weren't going to have Negroes home for supper, no matter what they said about the South: only kids like themselves—rich white kids! And they treated their servants with a lot more discourtesy than I ever saw my parents or my brother or sister treat ours. They ordered them around and never said thank you. They talked of servants as if they were so much scum. For us, the Negroes who worked in our house were part of the family, and their entire families were also part of our family. Look, I'm not justifying the South's history or the practice of segregation. I'm just trying to tell you about some of the strange facts of life, maybe they can be called, that you come up against once you start looking at the world a little closely, instead of just accepting everything and not asking questions. Of course, I have no answers to a lot of the questions I *have* asked, so I'm not sure I'm the best person to talk with. Oh, here I am apologizing—but it's a fact that life is pretty mixed up a lot of the time!"

He was not only apologizing but behaving very much like the black people who do indeed work in and around his home, even as others worked in and around his father's home, his grandfather's, and on and on. Like them he is modest, almost self-effacing. Like them he tries to be of help but doesn't make a show of his generosity or willingness to be of service. Like them he is at times quite puzzled: how to make sense of a thoroughly messy world—hard enough to analyze into categories that seem useful, never mind comprehend with assurance or satisfaction. Like them he is the last one to brag and boast, show swagger and impress others with all his virtues. But he has virtues, and he does not begrudge others' having them. I find him often shy, reticent; *inward* is the word. And though not very much a churchgoer, he thinks long and hard about *why:* why are we here and why is the world the way it is, and why don't things get better—and fast? He is hard-working and he is tactful. He has brought up fine children; they are, quite simply, like him. Or, as he would insist, he and his wife and their Negro friends who work with as well as for them (and there is indeed much sharing in the kitchen and pantry, in the garden) have *together* managed to bring up these fine children, even as he and his wife have meant so very much, as sources of inspiration, as examples, to the children of certain Negro people—a number of whose children have gone to college and are headed for professional schools. I end here, I hope, with no burst of nostalgia for the old plantation South, for the old tradition of *noblesse oblige*. If anything, it has too often been *noblesse oblige* on the part of blacks directed at their all too insensitive, if not callous and

vulgar, white "betters." But there are a number of whites well below the Mason-Dixon line who have all along looked at blacks with appreciation, gratitude and admiration. Perhaps Doris Ulmann, Yankee visitor that she was, belongs in their company. And perhaps many of us, upon receiving the gift of her work, will find ourselves feeling toward her as those white people of the South feel toward their black neighbors.

779 Ulmann, Doris

Darkness and the light.

DATE DUE			